Fernand Khnopff

Portrait of Jeanne Kéfer

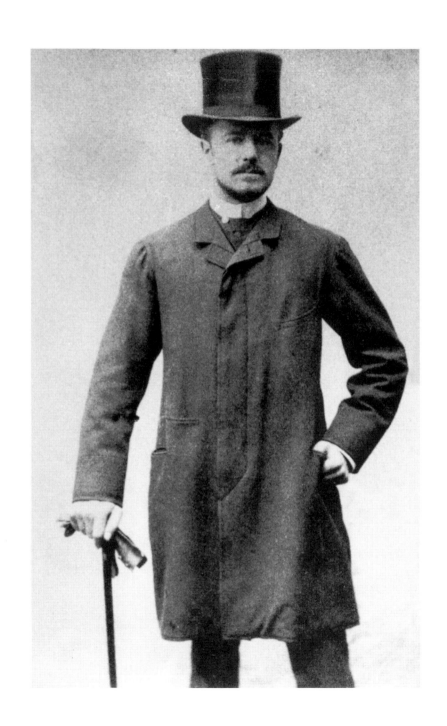

Fernand Khnopff

Portrait of Jeanne Kéfer

Michel Draguet

GETTY MUSEUM STUDIES ON ART

Los Angeles

© 2004 J. Paul Getty Trust

Getty Publications
1200 Getty Center Drive, Suite 500
Los Angeles, California 90049-1682
www.getty.edu

Christopher Hudson, *Publisher*
Mark Greenberg, *Editor in Chief*

Mollie Holtman, *Series Editor*
Charlotte Eyerman, *Curatorial Consultant*
Michael Lomax, *Translator*
Fronia W. Simpson, *Copy Editor*
Jeffrey Cohen, *Designer*
Suzanne Watson, *Production Coordinator*
Lou Meluso, Ellen Rosenbery, *Photographers*
Yvonne Szafran, *Photographer, Microphotographs*

Typography by Diane Franco
Printed in china by Imago

Library of Congress
Cataloging-in-Publication Data

Draguet, Michel.
Fernand Khnopff : portrait of Jeanne
 Kéfer/Michel Draguet.
 p. cm.—(Getty Museum studies on art)
 ISBN 0-89236-730-X (softcover)
 1. Khnopff, Fernand, 1858–1921. Jeanne
Kéfer. 2. Khnopff, Fernand, 1858–1921—
Criticism and interpretation. 3. Symbolism
(Art movement)—Belgium. I. Title. II. Series.
ND673.K4A54 2004
759.9493—dc22

 2003025850

CONTENTS

Final page folds out, providing a reference color plate of the
Portrait of Jeanne Kéfer

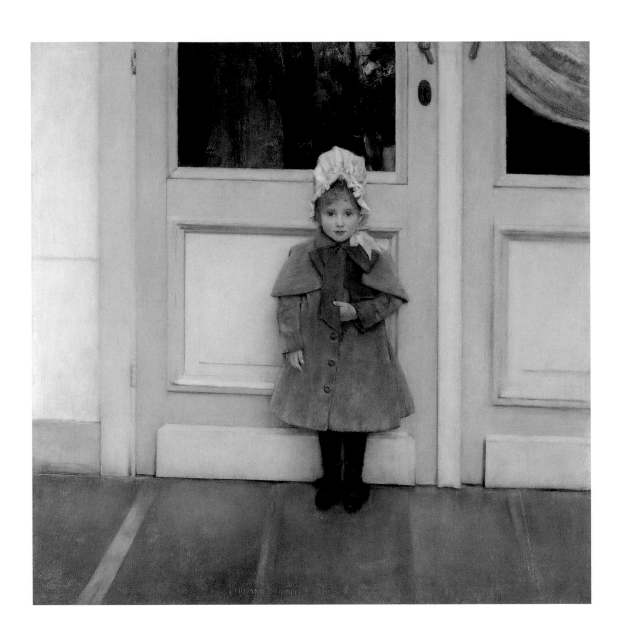

A Little Girl at the Center of the Avant-Garde

A small girl stands with her back to the door of a drawing room in a bourgeois residence in Brussels in the 1880s [FIGURE 1]. Her dress and the setting tell us that she belongs to the prosperous middle class that formed the backbone of Belgium, which had just celebrated the fiftieth anniversary of its independence from the Netherlands. Soberly dressed, Jeanne Kéfer fixes her eyes on the spectator with an intensity rare for her age. Unbound by time, a china doll in a coat of fine material, she observes us with the same power as a Fayum portrait or a Byzantine icon. But she is neither dead nor a saint. Indeed, her pose reflects the everyday practice of the commercial photographers who flourished at the time. The space to which she belongs is a typical Brussels interior: delicately painted walls, a glass-paneled door, a curtain visible on the other side of the door. Everything breathes the naturalness of everyday life; and yet few works have succeeded in revealing so much with such economy of means.

Magnified by Fernand Khnopff's brush, the little girl's presence is first of all testimony to an adventure begun a year earlier in Brussels: that of Les XX (The Twenty), or the Cercle des XX (Circle of Twenty), a group of avant-garde artists who, from 1884 to 1893, exhibited works by artists from across Europe chosen to incarnate the idea of modernity, from James McNeill Whistler to Vincent van Gogh, from Georges Seurat to James Ensor to Maurice Denis. Under the painter's brush Jeanne Kéfer also embodies, through the symbolic depth of the representation, a reflection on human life. This simple *Portrait of Jeanne Kéfer* is no simple painting.

When he painted the portrait of Jeanne Kéfer in 1885, Fernand Khnopff[1] already enjoyed a solid reputation and a level of success that made him one of the leading figures of the Brussels avant-garde. Despite his association with Les XX, the modernity that he defended was not intended to provoke

Figure 1
Fernand Khnopff
(Belgian, 1858–1921),
Portrait of Jeanne Kéfer,
1885. Oil on canvas,
80 × 80 cm (31½ ×
31½ in.). Los Angeles,
J. Paul Getty Museum,
97.PA.35.

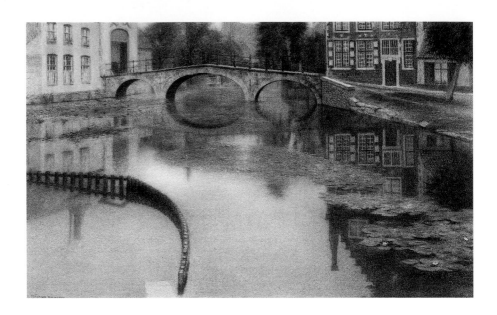

discomfort. His social status gave him a position in society that he used freely to advance his career as a portrait painter. His intelligence and his taste for literature placed him at the center of the new modernism, which was taking shape in the art journals and in the lively Brussels salons and studios of his day.

The son of a magistrate from an old aristocratic line, Fernand-Edmond Jean Marie Khnopff was born on September 1, 1858, at the family's castle in Grembergen-lez-Termonde, Belgium. In 1860 the family took up residence in Bruges, where his father had been appointed deputy public prosecutor. They stayed there until 1864, regularly returning to the castle of Grembergen or, in summer, to their country property at Fosset in the forest of Ardennes.

On September 7, 1860, Fernand's younger brother Georges was born. Although he was a poet, musician, musicologist, and translator, Georges did not leave any real oeuvre behind him. Perhaps because of his lack of output, he played a pivotal role in his brother's life. A friend of Stéphane Mallarmé, Jules Laforgue, and Émile Verhaeren, Georges was a confirmed Wagnerian who built up a wide network of contacts and championed his brother's work across Europe.

A promotion and the birth of a child, Marguerite, on July 15, 1865, occasioned the family's move to Brussels, where they set up house in the rue Royale, in one of the new districts favored by the Brussels bourgeoisie. Fernand later refused to return to Bruges so that he could retain intact his child-

hood image of the city; a series of works he produced in 1902 reveal a phantom cityscape dedicated solely to memory [FIGURE 2]. His relationship with Marguerite was a decisive factor in Fernand's life. She soon became one of his favorite models, as were the Maquet sisters, young Englishwomen with whom Khnopff remained friends for many years. Marguerite's features would become part of the feminine ideal that Khnopff was to create, in the early 1880s, from a mixture of Pre-Raphaelite figures and those from what at the time was called primitive Flemish painting, that is, painting from the fifteenth century. Marguerite was also her brother's collaborator in developing the compositions for which, as we shall see, Khnopff turned to photography for help [FIGURES 3, 4]. In the privacy of the studio, she would dress in various costumes and pose for her brother when he methodically put together the esoteric paintings that Hermann Bahr would call "logographs" (word puzzles)[2] when they were presented at the Vienna Secession.

Figure 3
Fernand Khnopff,
Photograph of
Marguerite Khnopff
Posing, ca. 1900,
for preparatory
version of *A Dreamer*,
ca. 1900. Private
collection.

Figure 4
Fernand Khnopff,
Photograph of
Marguerite Khnopff
Posing, ca. 1900,
for preparatory
version of *The Black
Collar*, ca. 1906.
Private collection.

After Fernand Khnopff completed his secondary education at the Athénée royale in Saint-Josse-ten-Noode, a suburb of Brussels, he enrolled, in 1875, in the law faculty of the Free University (Université libre) of Brussels. His taste for painting and literature was growing, and he wrote poetry and took classes with the painter Xavier Mellery. In 1876 the family moved to the Luxembourg district of Brussels, which included a sizable English colony, allowing Fernand to give free rein to his anglophile instincts and leading Émile Verhaeren to refer to him as a "clergyman in the process of becoming a dandy."[3]

Abandoning his legal studies, Khnopff enrolled at the Académie des Beaux-Arts in Brussels, graduating in 1879 with a third prize in historical composition. The summers of 1877, 1878, and 1879 were spent in Paris completing his training by studying the works of the masters there. His visit to the 1878 Exposition universelle proved to be a turning point. The works of Gustave Moreau, Edward Burne-Jones, and Alfred Stevens left an indelible impression on him, decisively orienting his development. After a year in Paris, during which he attended the independent lectures of Jules Lefebvre and the Académie Julian, Khnopff returned to Belgium in the summer of 1880. In Fosset he produced his first major work, a design for a monumental ceiling

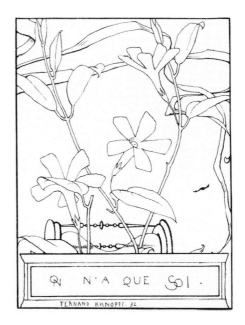

Figure 5
Fernand Khnopff,
*One Has Only Oneself
(On n'a que soi).*
Drawing for the artist's
ex libris, 1892. India ink
on paper, 8 × 6 cm
(3⅛ × 2⅜ in.).
Brussels, Bibliothèque
royale Albert 1er,
Cabinet des estampes.

painting for the house of his friend Léon Houyoux [FIGURE 6]. Exhibited in February 1881 at the salon of L'Essor, a group of former students from the Académie des Beaux-Arts, the work, with its allegorical subject matter, received a lukewarm reception from the critics. A few months later, Khnopff's canvas *The Crisis* [FIGURE 7] raised the ire of the conservative press when it was presented at the Exposition générale des Beaux-Arts of Brussels.

Figure 6
Fernand Khnopff,
*A Ceiling to Be
Completed on Site:
Painting, Music, Poetry,*
1880. Oil on canvas,
320 × 240 cm
(126 × 94 ½ in.).
Himeji City Museum
of Art.

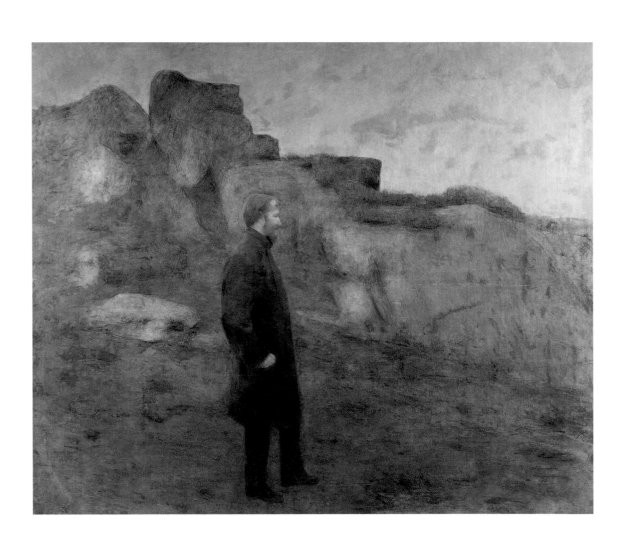

While Khnopff was facing hostile criticism, two new artistic and literary reviews—*L'Art Moderne* and *La Jeune Belgique*—that marked the cultural debate of the time appeared in Brussels. Among the Belgian art critics, the poet Émile Verhaeren referred to Khnopff's contribution to the 1882 L'Essor salon. Verhaeren, Georges Khnopff's friend, would be the first to promote the work of the young painter. In Fernand he detected a new sensibility that he designated as Symbolist as early as 1886 in his first study of the painter.[4]

The Crisis [FIGURE 7] embodies an attitude disseminated by *La Jeune Belgique*, the progressive review headed by the young writer Max Waller. The review, speaking for the group of the same name, sought to flee reality while expressing its resentment of a world of imposture. Disenchanted and prey to the illusions of reality, they posited, modern man sees his personality engulfed in doubt and pessimism.[5] Thought turns meaninglessly, hollowing out man's inner psychic space, constantly circling back on itself. For Khnopff, the portrait is a privileged place of interrogation where the gaze of the other is mixed with a search for one's own identity. Impenetrable, the face is also a promise, as the sensitivity of the *Portrait of Jeanne Kéfer* shows. Closed in on herself, a prisoner of her pose and her clothing, the child speaks her true self through the way she looks at the viewer.

Khnopff's painting enjoyed growing recognition in literary and artistic circles as his work branched out in various directions. Although his literary endeavors—influenced in particular by Gustave Flaubert—drew much unfavorable criticism, his faithfulness to the Flemish tradition of painting, visible in the landscapes and portraits that he exhibited, rapidly made him one of the most noted figures of the Brussels avant-garde.

Given his fame, it was only natural that he would take part in the meeting convened on October 23, 1883, at the Taverne Guillaume, next door to the Musées royaux des Beaux-Arts de Belgique, in response to the museums' refusal to hang James Ensor's *Woman Eating Oysters*. The painting had already been rejected at the Antwerp Salon one year earlier. The decision was made to secede from the Salon. Les XX[6]—originally just fifteen artists—brought together painters and sculptors of an avant-garde inclination, such as James Ensor, then the leading figure of a modernist style of painting nourished by the Flemish tradition; Théo van Rysselberghe, who later became the bard of Neo-Impressionism in Belgium; and Khnopff, who was tempted more by the literary circumvolutions of Symbolism.[7]

Figure 7
Fernand Khnopff, *The Crisis*, 1887. Oil on canvas, 114 × 175 cm (44⅞ × 68⅞ in.). Brussels, private collection.

7

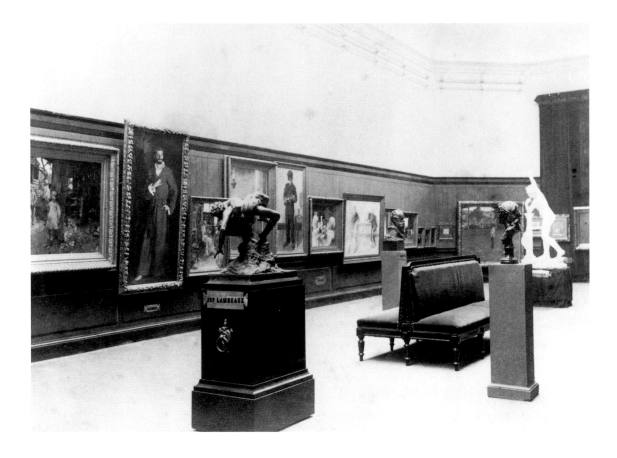

The exhibitions of Les XX stand out for their flexibility: every year three artists organized the exhibition, with a secretary looking after the day-to-day management of the association [FIGURES 8, 9]. At the general meeting, members listed the Belgian or foreign artists who would be invited to exhibit at the next salon. Each artist hung his own works, with the hanging spaces drawn by lot. The group decided to exhibit freely, without any selection or hanging committee, and to invite artists from abroad who demonstrated the same modernist spirit. After some hesitation, Octave Maus, an attorney training with Edmond Picard and a cofounder of L'Art Moderne, for which he wrote the articles on music, was offered the position of secretary. The review very quickly became favorably disposed toward Les XX, which was represented by a logo designed by Khnopff himself [FIGURE 10].

Announced several weeks in advance in L'Art Moderne, the first salon of Les XX opened its doors on February 1, 1884, at the Brussels Palais des Beaux

8

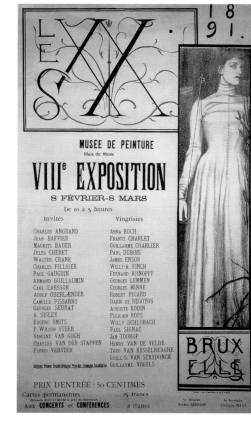

Arts. Borrowing Ensor's principle of multidisciplinarity, Les XX organized accompanying lectures and concerts. In an inaugural lecture, Picard identified the young group's artistic policy, which was radically opposed both to the world of academicism and to the Realist aesthetic. Rather, it saw itself as following a national tradition originally expressed by Peter Paul Rubens in the seventeenth century.[8] Picard defined three principles that members of Les XX would espouse: study of the nature and relevance of the subject; a constantly alert artistic sense; and perfect mastery of the craft with proper respect for tradition.

From the outset Les XX—adopting the program announced in 1881 by *L'Art Moderne*—rejected narrow attachment to any one movement or style. Because Les XX was based in Brussels, which was both an international cross-roads and the center of a modern national identity, the group "naturally" looked toward Paris. As it developed, the circle demonstrated an infatuation for certain artists and movements that, in their eyes, incarnated modernity

Figure 9
Fernand Khnopff, "Les XX. On y va." Letter from Fernand Khnopff to Octave Maus, 1884. Brussels, Archives de l'Art Contemporain, Musées royaux des Beaux-Arts de Belgique, 4625.

Figure 10
Fernand Khnopff, Poster for the Eighth Exhibition of Les XX in 1891. Brussels, Bibliothèque royale Albert 1er, Cabinet des estampes, SI 23258.

à la française: Whistler (whom Les XX considered French) in 1884, then Impressionism in 1886 and Symbolism in the figure of Odilon Redon, who had a considerable impact. In 1887 Neo-Impressionism imposed itself, dominating the movement to the end of the decade. At the beginning of the 1890s, the source of inspiration shifted to England. The ensuing concern with the renewal of decorative arts led, in 1893, to the dissolution of Les XX and the creation of La Libre Esthétique.

MUSIC IN THE STUDIO

P ainted in 1885, the *Portrait of Jeanne Kéfer* is emblematic of the adventure surrounding the formation of Les XX. Jeanne was born in Ixelles, a suburb of Brussels, on December 14, 1880, the daughter of the (short-lived) marriage of Mélanie Antoinette van den Broeck and Gustave Kéfer, whom

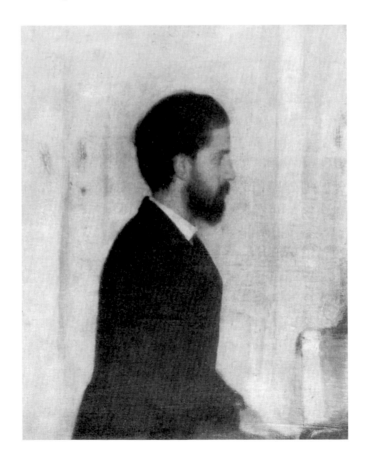

Figure 11
Fernand Khnopff,
Portrait of Gustave Kéfer, 1885. Oil on canvas, 24 × 10 cm (9½ × 3⅞ in.). Location unknown. Reproduced from R. L. Delevoy, C. de Croës, and G. Ollinger-Zinque, *Fernand Khnopff*, 2nd ed. (Brussels, 1987), p. 228, no. 74.

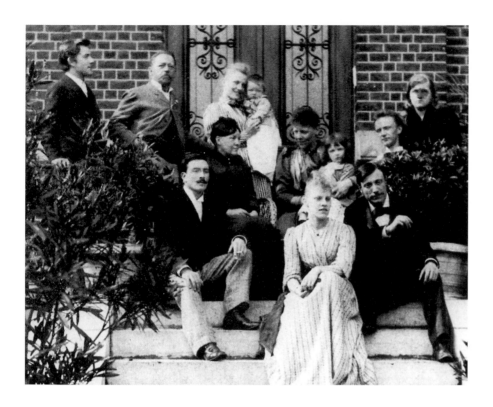

Khnopff painted in profile seated at his piano, also in 1885 [FIGURE 11]. Born in Jambes, near Namur, in 1855, Gustave was thirteen years younger than his brother Louis Kéfer, who became the director of the Conservatoire de Verviers. At the Brussels Conservatory, where he was enrolled from 1867 to 1877, Gustave followed the courses of Joseph Dupont and Louis Brassin, a disciple of Anton Rubinstein and one of Richard Wagner's first defenders in Belgium.[9]

A pianist and conductor, Gustave Kéfer founded in 1881 the ALBK Quartet (the letters stand for Agniez, Liégois, Buadot, and Kéfer), which became known for its regular concerts in artists' studios [FIGURE 12]. In 1882 he cofounded the Union Instrumentale, which followed the same policy, playing also at the Musical Mondays organized by Anna Boch,[10] the daughter of a wealthy pottery owner from La Louvière, at her house in Brussels. It is most likely there that Kéfer and his instrumentalist friends became closely acquainted with the capital's literary and artistic intelligentsia. Regular attendees at these Mondays included one of Anna Boch's cousins, Octave Maus, the secretary of Les XX. Perhaps Maus was the link uniting Kéfer with the circle of Anna Boch and, through them, with the avant-garde movement that was taking shape in Brussels. Maus, Gustave's junior by one year, also followed Brassin's

Figure 12
Photograph of Marie Sèthe outside Her Parental Home Surrounded by Her Family and Musicians. Gustave Kéfer is seated to her right in the front row. Private collection.

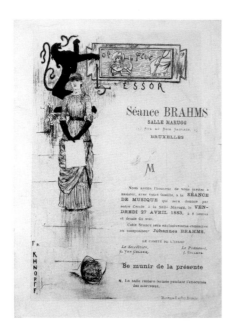

Figure 13
Program of the "Brahms
Session" Organized
by the Pianist Gustave
Kéfer on April 27,
1883, in Brussels, with
an Original Drawing
by Fernand Khnopff.
Vienna, Archiv
der Gesellschaft der
Musikfreunde.

piano courses, retaining his master's feverish commitment to Wagner, which would mark his own musical aesthetic.[11]

As the leading figure of the Union instrumentale, Gustave Kéfer moved in the same circles as the painters united under the aegis of Les XX. In 1883 the ensemble inaugurated concerts sponsored by L'Essor. A clear connection exists between Kéfer and Fernand Khnopff beginning in this inaugural year. Khnopff provided the layout and illustrations for the invitation to a concert of music by Johannes Brahms organized by L'Essor on April 27 [FIGURE 13].[12] On February 14, 1884, Les XX in turn called on Kéfer to inaugurate its own concert program at the Palais des Beaux-Arts,[13] with solo renditions of works by Giuseppe Domenico Scarlatti, Adolf Jensen, Edvard Grieg, and Rubinstein as well as a piano transposition by Brassin of Wagner's *Ride of the Valkyries*. The critical reviews speak of Kéfer as a powerful player in the Wagnerian register.[14]

In her 1926 memoirs, Madeleine-Octave Maus is less than enthusiastic about these first concerts at Les XX, whose programs, in her eyes, "were not in keeping with the innovative allure of the Salon."[15] Kéfer's memory would in any event be unable to hold its own against the energetic and decisive activity of Eugène Ysaÿe, a composer, conductor, and violinist, who soon imposed himself.

Kéfer's presence at the Les XX concerts was not limited to this first year. On February 26, 1887, the musical performance was devoted entirely to works by Louis and Gustave Kéfer.[16] According to L'*Art Moderne*, the concert attracted an audience of about five hundred. During a February 1890 concert sponsored by Les XX, Gustave Kéfer attested to his literary affinities as a composer[17] by setting to music several poems, among them "Religious Evening" (Soir religieux) from his friend Émile Verhaeren's collection *The Monks* (Les Moines).

By 1890, the concerts of Les XX were being organized by Eugène Ysaÿe, who gave less time to Kéfer. Kéfer no longer appeared on the programs, which were now directed toward the young French school. At the

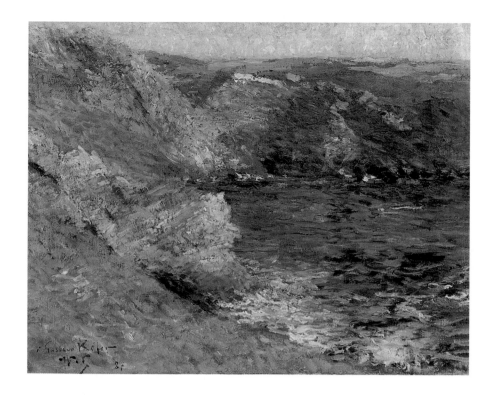

Figure 14
Willy Schlobach
(Belgian, 1864–1951),
The Cliff, 1887.
Oil on canvas, 32 ×
40 cm (12⅝ × 15¾
in.). Private collection.
Photograph courtesy
Henry Bounnameaux.

strictly anecdotal level, this 1890 concert is nonetheless interesting. It included, alongside those of Kéfer, works by Léon Soubre, which the latter, a teacher at the Brussels Conservatory, interpreted on the piano. Thirteen years later, on April 29, 1903, in Ixelles, his son Louis Soubre was to marry Jeanne Kéfer (they divorced in 1911).

According to members of the family, Jeanne played an active role in the history of Les XX when, in 1891, Maus decided to found "a vocal ensemble working specially for its concerts."[18] Jeanne was one of the twenty or so women and girls who met regularly on Wednesday evenings at Anna Boch's house to rehearse, under the direction of Soubre and accompanied on the piano by Maus.

From 1881 through the early 1890s, Gustave Kéfer appears linked with the Brussels avant-garde. His friendship with Verhaeren placed him at the center of literary life. Close to the producers of *La Jeune Belgique* and *L'Art Moderne*, he became friendly with such writers as Georges Eekhoud and Eugène Demolder. Demolder dedicated a story to Kéfer in his collection *The Slaughter of the Innocents* (*La Massacre des innocents*).[19] The musicians were joined by painters. Through Verhaeren, Kéfer became friends with Willy Schlobach, a founding member

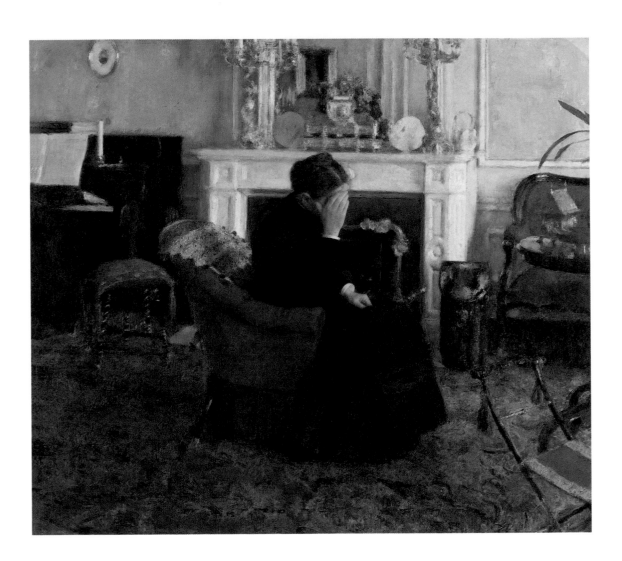

of Les XX, a painter with frequently changing sources of inspiration [FIG-URE 14]. In 1887 Schlobach dedicated to Kéfer a landscape painted under the influence of Claude Monet.

Despite gaps in the archival evidence, it seems logical to suppose that Gustave Kéfer and Fernand Khnopff were closely associated, with the painter's brother Louis probably playing the role of intermediary. In addition, Kéfer was a friend of Verhaeren's, and the poet was as confirmed a Wagnerian as the pianist. Both of them gravitated toward *La Jeune Belgique*, frequenting the same circles. Khnopff shared their enthusiasm for music and poetry. This close friendship between the Khnopff brothers and Verhaeren is set in both Brussels and Fosset, the little village in the Ardennes where the Khnopffs had their summer residence. Fernand's representation of reality through landscapes and still lifes testifies to a sense of meditation and interiority close to Verhaeren's poetry of this period.

The climate of sullen melancholy that haunts Gustave Kéfer's setting of Verhaeren's "Religious Evening" mirrors the neurotic grisaille tones of Khnopff's painting *The Crisis* [FIGURE 7]. A yearning for the metaphysical and dispossession of the self can be found in each. Khnopff's bonds with music appear to tighten around the years 1883 to 1885. In addition to the portraits of Jeanne and Gustave Kéfer, Khnopff also depicted the violinist Achille Lerminiaux, another member of the Union instrumentale. But the closest tie with the world of music in Khnopff's oeuvre is probably to be found in a psychological portrait of his mother that he painted in 1883. In *While Listening to Schumann* [FIGURE 15], the painter sought to portray the effect of music, which he symbolizes by equating hearing with vision and meditation with social activity. The work, which Verhaeren referred to as a "study of the soul,"[20] reflects the suggestive powers that Khnopff attributes to music. Music gives birth to an interior vision in which the world of conflict displayed in *The Crisis* is resolved in aesthetic sensation.[21] Verhaeren added to this a dimension of melancholic retreat. For him, the work

> carries the viewer beyond exterior things, reflecting an aspect of the contemporary soul. It is only in the past few years that we have listened to music in this way—not from a sense of pleasure, but with meditation. The effect of art, of our art, is to help produce a vague attraction toward a sad, serious ideal.[22]

In this way, the idea of musicality is posited at the heart of Khnopff's work, supporting the idea of solitude that, in another register, was to leave its mark

Figure 15
Fernand Khnopff, *While Listening to Schumann*, 1883. Oil on canvas, 101.5 × 116.5 cm (40 × 45⅞ in.). Brussels, Musées royaux des Beaux-Arts de Belgique.

on Symbolist portrait painting as demonstrated in his depiction of Jeanne Kéfer [FIGURE 1].

The portrait of Jeanne Kéfer invites the viewer to witness the gradual formulation of pictorial Symbolism. One year before such writers as Jean Moréas, Gustave Kahn, and Émile Verhaeren set out their theory of Symbolism, Khnopff writes about this widening of reality to include the realms of a dream that is "indistinguishable from life."[23] The formula Verhaeren used in 1886, precisely in reference to Khnopff, sums up a step that he describes in decisive words:

> For persons wanting to define the dominant lines of the new school: "Nature seen through a temperament" is the famous formula of Naturalism. "Temperament seen through nature and even without nature" would appear to be that of the innovators. The

poles have been reversed. Reality and the brain are the two players in any art. Which of them will dominate? Naturalism answers that the brain should serve solely to render the realities of nature. Symbolism answers that nature is no more than a handmaid for rendering the dreams of the brain.[24]

Cerebral, but based on an intense sensitivity, Symbolism testifies to a desire to transcend reality that involves, not the evocation of an ideal elsewhere, but a new reading of the here and now. In this context the *Portrait of Jeanne Kéfer* is decisive, as it is through this—at first glance conventional—representation of a young girl that Khnopff sets the basis for his concept of the portrait, which will soon be accepted as the criteria for Symbolist portrait painting.

In addition to a portrait of his father painted in 1881, those of Gustave Kéfer and Achille Lerminiaux [FIGURE 16] are among the first portraits painted by Khnopff. Their small formats—24 by 19 centimeters and 16 by 16 centimeters, respectively—remove any possibility that they were painted on commission. Perhaps they were sketched during a studio recital or a concert at the Brussels Cercle Artistique et Littéraire to which both musicians, like Khnopff, belonged. Unless, that is, the depictions were made at the Brahms evening organized in 1883 (whose invitation Khnopff designed) or at one of the first two concerts sponsored by Les XX in 1884. The lack of detail and the summary settings also suggest such an informal origin.

The same cannot be said of the portrait of Jeanne, which, because of its size and the quality of its execution, was immediately recognized as a major work. This is evident by the list of exhibitions in which the painter himself included it. First announced for the Salon of Les XX in 1885, it was not exhibited there, as Khnopff, short of time, canceled his participation at the last minute.[25] It did appear at the 1886 salon[26] and then, one year later, at Antwerp, as part of *L'Art Indépendant*.[27] Once recognized, the portrait went on an international journey, being shown at the 1892 exhibition of London's Society of Portrait Painters,[28] then, in 1896–97, at Florence's Festa dell'Arte et dei Fiori,[29] before being included in the Munich Secession's annual exhibition in 1898.[30] Applauded by critics at exhibitions, the painting also figured in the main studies devoted to Khnopff.[31] This recurrence is significant given that they were all written under the painter's attentive supervision. All the authors praise this painting for its technical mastery worthy of the primitive Flemish masters who were only then being rediscovered. The authors write that they sense that an original form of Symbolism, divorced from any esoteric concerns, is about to be expressed. In this way the painting takes its place both as an important

milestone in Khnopff's oeuvre and as evidence of his contribution to fin-de-siècle art.

WHISTLER IN BRUSSELS

As well as demonstrating the bonds between Khnopff and the Brussels musical world of the late 1800s, the *Portrait of Jeanne Kéfer* reveals the enthusiasms of Les XX. With its dominant gray, blue, and green harmonies and its measured brushwork, the portrait demonstrates the profound, though short-lived, influence exercised by James McNeill Whistler on the Brussels avant-garde.

In 1884 and again in 1886 and 1888, the work of Whistler—who had already made an impact on a number of artists of the earlier generation, such as Alfred Stevens—was exhibited at Les XX's salon. In 1884 he simultaneously impressed several painters,[32] chief among them Khnopff, both with his iconography and with his paint handling, which were dominated by the idea of musicality. With *Rose and Japanese Fan* [FIGURE 17], painted about 1885, Khnopff pays his debt to the fashion for Japanese art by picking up the symbolic tools of Whistler's *Symphony in White, No. 2: The Little White Girl* [FIGURE 18]. The *Portrait of Jeanne Kéfer* in turn reveals a more fundamental relationship with Whistler.

In the early 1880s Whistler was looking for a stage, which England appeared to deny him after his disastrous libel suit against John Ruskin. Although the painter won the lawsuit, court costs forced him to declare bankruptcy. Deserting a national scene that in his eyes was too narrow, he entered the international arena, riding the Secessionist wave of the end of the century.[33] This probably explains the warm reception he enjoyed in Brussels. In the works Whistler exhibited there in 1884,[34] the young painters discovered the full palette of Whistler's imaginary world: the melancholy slackness of *The Little White Girl*, the musical harmonies of the Nocturnes, and the mastery of the settings, both somber and *recherché*, in the

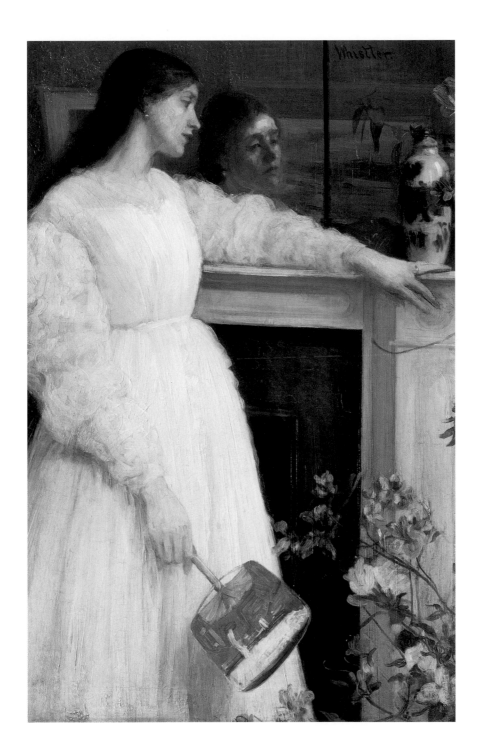

portraits included under the generic category of "arrangements." Through Whistler, the Belgian painters discovered a science of harmony based on the musical use of the palette. Light casts this unity into a series of balanced chords of tones, tints, lines, and shapes. Through his symphonic compositions, Whistler opened the way to an Impressionism that moved beyond the framework of Realism to lay the foundations of a Symbolism that encompasses both landscapes and portraiture: witness Jeanne Kéfer, appearing all in blue and gray in Khnopff's portrait. Like music, Whistler's work emphasizes an interior reality that goes beyond the simple translation of the object seen by the artist, sublimating it into decoration. Joris-Karl Huysmans speaks of this in an essay of 1883 published in *L'Art Moderne* the following year:

> Invincibly, our minds turn to [Thomas De] Quincey's [English author of *Confessions of an English Opium-Eater*] artificial paradises, to those riverscapes, to those fluid, opium-induced dreams. In their pale gold frames, with their blue-turquoise vermicelli and dotted with silver, these sites of air and water flee into the infinite, transporting you into a magic yet natural world, evoking countries beyond reality, calling on the mind to travel, suggestive of pampering with strange impressions.[35]

Impressions derive not from what is seen but from the imagination, which metamorphoses reality into the realm of artifice. For Whistler, this artifice is no illusion, but the transposition into an idealized mode of a splintered reality that can never be reduced to purely naturalistic transcription. The idea of the series plays a key role here. In both portraits and landscapes, constantly returning to the same faces or the same places, the painter moves beyond outward appearances to seize the indecipherable that rises up out of the subject in front of him. Beyond appearance there comes into being a meaning based less on the subject in itself than on the harmony introduced in the image. As Whistler stated in his essay "Red Rag": "As music is the poetry of sound, so is painting the poetry of sight, and the subject-matter has nothing to do with the harmony of sounds or of colours."[36]

Is it not here that Khnopff finds a principle that animates what is essential in his portrait painting and that justifies the gap, however small, that separates each model from its painted representation? Does this mean that the portrait exists only in the idea of series and, through this idea, in the progress induced by repetition? From *Jeanne Kéfer* [FIGURE 1] in 1885 to *Arum Lily* [see FIGURE 76], painted ten years later, via the portrait of his sister Marguerite

[see FIGURE 75], Khnopff developed the same staging of the woman he represents, passing, gradually and methodically, from her familiar appearance to her dreamlike metaphor, from reality to symbol.

During this shift, the symbolism becomes visible in the alchemy of sensations that turns the image into the absolute that Verhaeren defined in *L'Art Moderne* as the attempt to "draw across one's brain [what the eye has seized of reality] and to color it in the way it feels and imagines."[37] Through Whistler, the theory of "art for art's sake"—a notion that was at the very basis of the American painter's aesthetics[38]—reappears and is defended by *La Jeune Belgique*. The *Portrait of Jeanne Kéfer* constitutes in this way the first stage of a process that gradually detaches itself from material reality to tend toward what are for Verhaeren "superb nonrealities." It sets the stage for a process of abstraction that, through the senses, provides us with one of the first definitions of the developing Symbolist approach. Khnopff, like Whistler, reveals himself here as a "painter of the immaterial, a harmonious arranger, an evoker of beings and personages,"[39] to use Verhaeren's description of the American from whom Khnopff borrowed something of his "science of the image," based entirely on the instrumentalization of shapes and colors.

Whistler's explosion onto the Belgian art scene exercised a profound—albeit short-lived—influence, which we shall return to later. Turned down in his attempt to join Les XX, he lost most of his predominance when Neo-Impressionism imposed itself in 1887 as the sole expression of modernity in painting. Using light to orchestrate color, the Pointillist technique supported by Seurat's chromo-luminist system would never have taken root in Brussels had not Whistler's example produced, between 1884 and 1886, this "musicalization" of painting that the *Portrait of Jeanne Kéfer* set out to exemplify.

The painting that Khnopff produced in 1885 reveals the issues dominating artistic debate in Brussels at the time Whistler was exhibited at Les XX. The fundamental objective was to move beyond Realism by orchestrating harmonies so as to make the image a self-contained truth, and, at the same time, through a sensibility that went beyond the exactitude of appearances, to move deeper into a reality that was dependent less on its visual representation than on the psychological understanding of it.[40] Beyond the eclecticism of styles and manners, the sensation of psychological penetration was to constitute for Verhaeren one of the characteristics of the Symbolism that he helped formulate, from 1886 onward, in his articles on Khnopff. In Whistler and Khnopff we find the same search for the ineffable, more in nuance than in dogma, as if the "exterior modernity"[41]—which Verhaeren also helped to define—was echoed by an "interior modernity" made up of sensation

and ideas, of intuition and concepts. This Symbolism, which magnifies the *Portrait of Jeanne Kéfer*, followed naturally from the model of Whistler as the poet Stéphane Mallarmé had occasion to define it in his interpretation of Whistler's *Ten o'Clock* lecture:

> Starting from the thing as seen, heard, touched and tasted, to evoke it and summarize it by the idea. . . . The symbol thus constantly purifies itself, through an evocation, into an idea: a sublimated object of perceptions and sensations, not demonstrating but suggesting. It is the death of all contingency, all fact, all detail. It is the highest expression of art and the most spiritualist expression possible.[42]

Symbolism, as Verhaeren proposes it, defines the modernity of Khnopff's oeuvre. In the early 1880s this took the form of a series of paintings—landscapes, still lifes, and portraits—in which the principle of suggestion imposes itself, free from strict mimetic representation. The *Portrait of Jeanne Kéfer* summarized this principle at the same time that it opened the way to new explorations.

PRODUCING A PORTRAIT

W histler provided Khnopff with the model he needed to unshackle himself from the realism of classical portrait painting. While the "documentary" function remained central in an art form often produced on commission, Whistler's idea of "arrangement" moved away from the pretext of the subject to confirm painting as painting. The idea of "arrangement" opened the way to the principle of "harmony," abandoning any concern for the narrative content of the work. The meaning of the portrait no longer depended solely on its subject; it was now rooted in a science of composition and a philosophy of creation that included the image in a wider questioning of the principle of representation.

A REALIST TRADITION

A fter a small number of trial paintings using family members or friends as subjects, in 1883 Khnopff produced the *Portrait of Mademoiselle van der Hecht* [FIGURE 19]. This portrait sets the general outlines for that of Jeanne Kéfer [FIGURE 1] two years later. The model, a little girl of four, was the daughter of Henri van der Hecht, a landscape painter and engraver whom Khnopff no doubt met at the Cercle artistique et littéraire, to which both belonged.[43] Like that of Jeanne Kéfer, this portrait refers back to the artistic milieu in which Khnopff evolved.

Presented one year later at the first salon of Les XX, the painting was seen by some as a delicate miniature—a "real jewel" according to Jules Destrée[44]—in which art and the ideal come together.[45] The sense of refined synthesis that the criticism expresses is significant, as the painting betrays two aspirations. On the one hand, the virtuosity of the brushwork is anchored in

a Flemish tradition of lyricism and the physicality of the paint itself, and, on the other hand, we have the virtually surgical precision of the drawing. In its mode of manufacture, the painting participates in the debate dominating the Belgian avant-garde in the early 1880s. In addition to providing the common denominator of the irregular band of Les XX, Realist aesthetics also showed a direction for the constitution of a national identity based on the Flemish tradition. In his *Histoire de la peinture en Belgique*, published in 1905, Camille Lemonnier defined this shared trend: "Producing wholesome, strong, original painting; returning to the true meaning of the painting, loved not for the sake of the subject but for its own rich materiality, as both precious substance and living organism; painting nature in its reality, its frankness, its accent, detached from known masteries and systems."[46]

This painting rejects the primacy of the subject, freeing itself from the intellectuality associated until then with the image, to restore what Lemonnier was to refer to as "wild sensuality" and turn the artist into both visionary and primitive. The painting is instead anchored in the sensuality of a gaze that is one with the movements of the paint.

The realism appears conditioned by practice: brushwork, generous impastos, and a strong palette become vehicles for sensibility in action. This sensibility sees itself as guaranteeing the objectivity of the act of seeing. The demand for instantaneity in the act of seeing led representation into new territories soon qualified by the name Impressionism. A dialectic began to take shape between the immediacy of sensation and the objectivity of the act of seeing that defines this spirit of analysis; Émile Zola would be one of its first theoreticians. In this way the artist becomes a liaison between reality that exists as such and the reality of the independent image. Contemplation[47] no longer passively follows the commonplace of the photographic act of seeing, to which we shall return; rather, it is inspired by psychology to make vision into a tool for exploring reality from the inside.

Realism and the study of nature are the foundations of this modernity, of this "true art" that *L'Art Moderne* sought to defend against academic conventionalism. Moving beyond and outside the framework of the traditional schools, this new aesthetic sought to set itself up as an international avant-garde. Beginning in 1884, Les XX would become the mouthpiece of this avant-garde.

Figure 19
Fernand Khnopff,
Portrait of Mademoiselle van der Hecht, 1883.
Oil on canvas, 37 × 29 cm (14⅝ × 11¾ in.).
Brussels, Musées royaux des Beaux-Arts de Belgique, 3980.
Photo: Cussac.

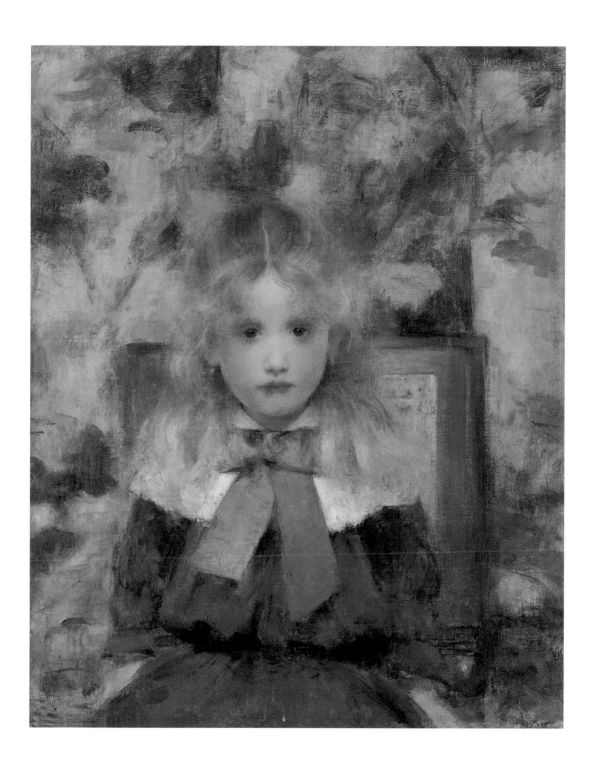

Around 1880–83, Khnopff's work developed largely within this context of a Belgian Realism that combines lyricism of brushwork with the quality of the impression. This is less a matter of sensation—as in France—and more a matter of expression. It is rooted more in a lyrical projection than in an internalization of perception. The landscape becomes the vehicle for a lyrical search inscribed in sensation. For Khnopff, the effect of the paint handling reflects less the vehemence of the gesture than the sensuality of a highly decorative script. The keys compose a harmonious score, which is closer to a murmur than to the scream dear to Ensor. Here, too, we see Whistler's influence: rising out of reality, the landscape transforms itself into dreamlike vision.[48]

The titles of the paintings themselves—*Passing Sun, Autumn Sun, The First Cold Days, A White Day, Toward Noon, At Fosset: Rain* [FIGURE 20]—reflect this "calm absorption of all things,"[49] a phrase Verhaeren uses broadly to define the Khnopffian landscape. Verhaeren is right in insisting on the atmospheric quality of the oeuvre. This is not to be understood in its Impressionist dimension. What we have instead is a pantheist form of symbiosis, with nature superseding the human figure.

When it appears in Khnopff's work, the portrait immediately internalizes this suggestive power. The *Portrait of Mademoiselle van der Hecht* [FIGURE 19], painted in 1883, testifies to the painter's anchoring in a Realist vein. Khnopff contents himself with using brushstrokes without seeking the powerful effects of the palette knife, with which, contemporaneously, Ensor drew severe criticism in his status of leader of the radical wing.[50] Where Ensor's gesture—tangible in *The Lamp Lighter, The Convalescent* or *The Lady in the Blue Shawl,* or *The Roofs of Ostend* [FIGURE 21]—fragments the surface to allow the pasty paint to spread and the color to crackle, Khnopff exerts his sense of control by spreading the paint thinly across the canvas.

Khnopff prefers rigorous calligraphic strokes to frenetic brushwork. The very construction of the *Portrait of Mademoiselle van der Hecht* demonstrates a strict control of brush effects. The heavy tapestry in the background closes off the composition by accentuating the integrity of the surface. Khnopff rejects depth: space, from the foreground to the background tapestry, is conceived as if it were a thin, flaky pastry, a delicacy further underlined by the bare architecture of the chair, which frames and isolates the little girl. A prisoner of her own outline, she cannot dissolve into the tapestry behind her even though Khnopff plays a game of chromatic echoes that moves the eye from foreground to background, unifying the image. Within this system, the hair plays

a symbolic role by promoting the passage from the face to space. The movements of the brush are purposely vaporous in order to dilute the space into a flux, whose movement leads to the girl's face, making its static features stand out in an even more troubling fashion.

The attentive child is stiffly rooted in her pose. Under the uniform of model little girl, her tense spirit bursts out, toward the viewer. The model's strength appears in the power of a gaze that organizes the composition: the symmetry of the eyes determines the vertical axis underlined by the parting of her hair, the bridge of her nose, and her blue silk bow; horizontally, it strengthens the back of the chair, isolating the body from the rest of the space.

From space to the gaze, from the vaporous to the fixed, from the pictorial gesture to the lightly drawn line, Khnopff modulates his effects to affirm a presence that is at once immobile and dynamic. A work of synthesis between space — treated here in the prolongation of the face — and the figure, the *Portrait of Mademoiselle van der Hecht* testifies to a concern for harmony that also includes an economy of palette. The blue of the girl's dress combines coldness and suaveness. The painting's uniform atmosphere exudes delicacy and fragility. The painter rejects the painterly effects dear to the Realists, spreading his colors instead in wafer-thin glazes. Critics such as Jules Destrée would reproach him for tepidness, interpreted as a "lack of robustness."[51] Khnopff seeks more the preciousness of a sapphire. In the diffuse atmosphere accentuated by the vagueness of the blond hair, the face alone appears with its perfect design, the artist using mother-of-pearl tonalities to render the finesse of the flesh tones. Khnopff creates a sense of movement that whirls up from the tapestry, gradually calming as it reaches the face to allow the eye to caress the pearlescent pink of the girl's cheeks, which emphasizes the sensuality in the drawing of the lips. This sensual attraction clashes with the determined look that arrests the spectator and pushes him outside the frame. Khnopff progressively deploys every artifice to distance the body from the world surrounding it, to cleanse it of everyday contingencies, to blur the contours of reality, and to restore to the gaze its dreamlike power.

The *Portrait of Jeanne Kéfer* continues the concerns of the portrait of Louise van der Hecht [FIGURE 19] he painted two years before. Reference to a Realist aesthetic has become more tenuous. The broad tapestry underlining the plane of the pose is replaced by a restrained formula that plays on the theme of the painting within a painting that Khnopff was to use regularly to multiply the degrees of reality, as in *I Lock My Door upon Myself* (1891). The glass pane of the door against which the child stands [FIGURE 22] circumscribes a space devoted to this paintbrush rhetoric that defines Belgian Realism. Here it

plays a double role, on the one hand creating the only field in which Khnopff, still attached to Realism, can give free rein to a painterly handwriting that, albeit controlled, remains gestural [FIGURE 23]. Khnopff uses a palette knife to underline the opacity of the paint surface. On the other hand, the pane of glass closes off the perspectival effect begun by the movement of the floor by reflecting the wall opposite it.

Rigorously inscribed within the plane, the representation suggests an atmospheric depth by operating from one end of the room to the other—that is, from the window that separates the rooms of the apartment to the window that looks out onto the street—without, however, defining a constructed space. Reduced to a detail, the Realist handling now becomes part of the process of isolation that characterizes the Symbolist practice of portrait painting. The pane of glass takes on a double meaning: as a symbolic expression of the actual image and as a questioning of the representation as reflection. The solitary image acquires stability from the window's square format, in which the composition finds balance and permanence.

AN "ARRANGEMENT" À LA WHISTLER

From *Mademoiselle van der Hecht* to *Jeanne Kéfer*, Khnopff continued to reflect on the purpose of the portrait. The exhibition of his first portrait of a child at the Les XX exhibition in 1884 provided the painter with the occasion for furthering his exploration by being able to compare his own work with that of Whistler, which was exhibited at the same salon. The intellectual dimension of his work, already emphasized by Émile Verhaeren[52] and many of the critics, was to be amplified by a Whistlerian reading of portrait painting. This encounter proved to be hugely enriching. Khnopff was struck by the solutions Whistler achieved in *Harmony in Grey and Green: Miss Cecily Alexander*, presented in Brussels in 1884 [FIGURE 24].[53] Like his portrait of Thomas Carlyle — also produced in 1872–74 — that of Cecily Alexander is presented by Whistler as an "arrangement,"[54] mixing decorative fantasy with the requirement for a realistic portrait. Whistler's correspondence between 1872 and 1874 with Cecily Alexander's parents reveals this concern for exactness. No detail of the portrait would be left in the shadows, and the posing sessions would be long and prepared for meticulously. It is out of the question for the painter that the portrait as such should depart from the strictest realism. The white of the dress can never be based on an effect of the imagination. Whistler went so far as to order Cecily's mother, Rachel Agnes Alexander, to have a dress made from white Indian muslin to avoid any bluish reflection, even listing his preferred suppliers.

The staging begins with the pictorial definition of the costume on which the model's pose will depend. The search for perfection assigned to the work goes beyond the portrait to begin a dialogue with its pictorial reference, Édouard Manet's *Lola de Valence*. The obvious similarity of the pose transforms

Figure 24
James McNeill Whistler, *Harmony in Grey and Green: Miss Cecily Alexander*, 1872–1874. Oil on canvas, 190.2 × 97.8 cm (74⅞ × 38½ in.). London, Tate Picture Gallery, N04622/111.

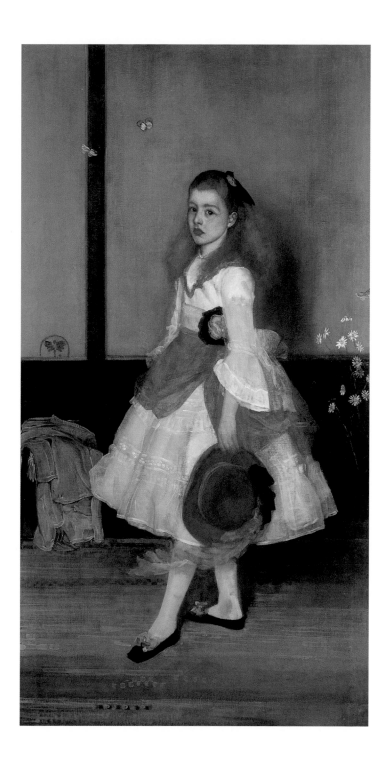

the anecdotal aspect of the portrait by emphasizing its artificiality, with the play of the decor as staging. The gray wall with its black wainscoting and the black-and-white striped carpet define geometric registers that, distributed across the surface, arrest the movement of the body, suspending it in space with neither shadow nor depth. Like a flower in an herb garden, Cecily Alexander, a very real person, floats in a dream outside reality. Like the flight of a butterfly, she belongs to the symbolic universe of the painting.

The painting, the result of a search for harmony, breaks with Victorian portrait conventions. The child does not appear as an angel but rather as the hostage of the pictorial fiction inscribed by her pose. Unlike the children painted by Sir John Everett Millais, Cecily does not appear like "a little girl posing freely and of her own will for her portrait."[55] Indeed, Whistler's *Harmony in Grey and Green* [FIGURE 24] was panned by the critics as an "arrangement of silver and bile" and a "nasty description of a nasty little girl."[56] In 1881 the *Magazine of Art* described the work as "a rhapsody for badly brought up children and spiders' webs."[57] What the press picked up as faults are no doubt prejudices that Khnopff would share. The *Portrait of Mademoiselle van der Hecht* [FIGURE 19] shows the same capacity of the child to resist the painter, whom she confronts with the magnetism of her gaze. The very ambiguity of the portrait, evolving between sensuality and reserve, reflects a paradoxical staging found also in the portrait of Cecily Alexander [FIGURE 24]. Responding to the sour and reserved face are the symbolic details of an affirmed femininity. An arrangement in gray and green, the portrait expresses a tension between the desire of the child and the requirements of the painting. In this way the principle of harmony is dependent not only on a decorative vision but on moving beyond this tension. While paying little attention to the child as a model, Whistler respects her for resisting him. Her opposition constitutes a key element of the "arrangement" that, through the image, imposes a relaxation. Huysmans was not mistaken in his description of the work, published in *L'Art Moderne* in 1884, when he insisted on the atmospheric quality that authorized him to see "a blond, anemic little aristocrat, cavalier and soft, an English infanta moving in an atmosphere of gray, gilded underneath with a patina of old vermeil."[58] By its characteristic play of echoes, the palette permits the unwilling model to fuse with the theatrical decor that surrounds her. Between the black wainscoting and the white of the dress, a range of grays and greens converse and interact with one another. The transparency of the muslin emphasizes a sensuous presence on which butterflies and flowers confer their symbolic quality.

Confronted with this work, Khnopff was very taken by its harmony, which moves beyond strictly Realist doctrine. Transposed into the painting, Cecily Alexander's resistance reveals the reticence of Realist objectivity faced with the idealization of the representation. Posing "just as one is" ran radically counter to the conventions of portraiture. Whistler has clearly sought to make this opposition the subject of his work. Using the idea of "arrangement," he questions the double nature of the portrait in order to sublimate it into a single principle requiring a spatial distancing and the suspension of time through the artifice of a theatrical setting, which moves from the decor to the palette via Symbolist detail. Time in the portrait is a time of harmony, which escapes strictly Realist representation.

THE ENIGMA OF PLACE

A comparison with the *Portrait of Mademoiselle van der Hecht* [FIGURE 19] reveals the innovations introduced in the *Portrait of Jeanne Kéfer* [FIGURE 1]. The setting picks up the essential elements of the principles that Whistler had affirmed. The originality of the composition lies no longer in the organization of its various elements but in a genuine desire to construct something. Viewed full length, like Cecily Alexander, the child appears imprisoned in the space surrounding her.

It was here that, for the first time, Khnopff elaborated a system that would become a part of his symbolic imaginary world. The body is always enclosed inside its contour line. Radicalizing the position taken in the *Portrait of Mademoiselle van der Hecht*, Khnopff stages his composition in registers. The head, body, and legs of Jeanne Kéfer form three separate parts that are repeated in the motif of the door. Enclosed in the field described by the door, the child is symbolically framed by these various elements. Khnopff defines here a setting that he would reuse in 1889 for the portrait of his sister Marguerite [see FIGURE 75]. The relationship uniting the body of the woman with the recess of the door in which she has been perfectly inscribed is affirmed here with an obvious symbolic rigor. Khnopff plays with the proportions to associate the two motifs even more closely: just like a door, the body blocks access to another reality that, being unconscious, is necessarily obscure. What the portrait of his sister presents with rigor, the *Portrait of Jeanne Kéfer* as yet sketches out hesitantly. In the latter, the body and the door have yet to find their perfect analogy. Between the chance aspect of the pose and the desire for staging, the symbolic

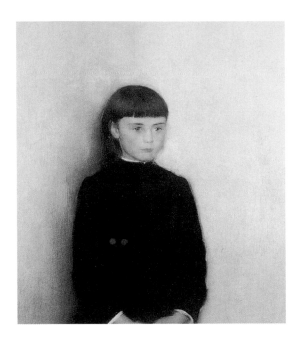

Figure 25
Fernand Khnopff,
*Portrait of Émilie
t'Serstevens*, ca.
1885. Oil on canvas,
64.5 × 55.5 cm
(25⅜ × 21⅞ in.).
Private collection.

Figure 26
Fernand Khnopff,
*Portrait of Isabelle
t'Serstevens*, ca.
1885. Oil on canvas,
64.5 × 55.5 cm
(25⅜ × 21⅞ in.).
Private collection.

opposite
Figure 27
Fernand Khnopff,
*Portrait of Eugénie
Verhaeren*, 1888. Oil on
canvas, 41 × 32.5 cm
(16⅛ × 12¾ in.).
Brussels, private
collection. Photo © Dick
Beaulieux, Brussels.

codification evident in the *Portrait of Marguerite Khnopff* remains empirical in the *Portrait of Jeanne Kéfer*.

The meaningfulness of the decor is confirmed by a comparison with the portraits that Khnopff painted from 1885 onward. In many of them he opted for an abstract, almost bare background—as in the portraits of the t'Serstevens sisters [FIGURES 25, 26] or in the *Portrait of Eugénie Verhaeren* [FIGURE 27]. He also retains the curtain motif—for example in his 1887 *Portrait of Marie Monnom* [FIGURE 28]—or its Whistlerian transposition as wallpaper—in the *Portrait of Gabrielle Braun* [FIGURE 29].

To these formulas Khnopff adds yet another, which will constitute a key element of the symbolic quality of the portrait: the integration of the figure into its architectural framework. This allows him to break with the traditional figure-ground dialectic by symbolically fusing the model with the place in a visually unified space: that of the image. From the *Portrait of Jeanne Kéfer* to the hermetic *Arum Lily* [see FIGURE 76], the theatricalization of the place stages a figure withdrawn from reality, moving in a space that is its spiritualized projection. In this way the image moves toward the icon, which reveals itself to be hermetic.

The portrait becomes less clear, less self-evident, and more difficult to understand. Stripped of all accessories, it nonetheless exhibits certain fun-

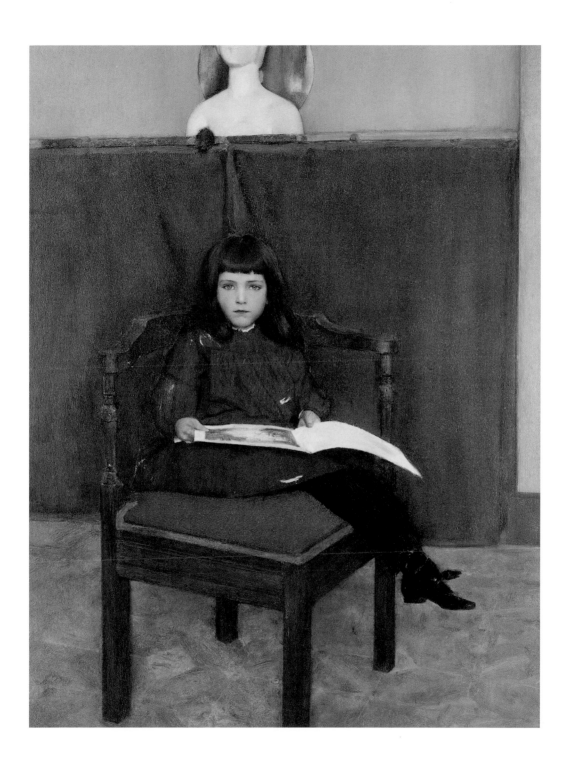

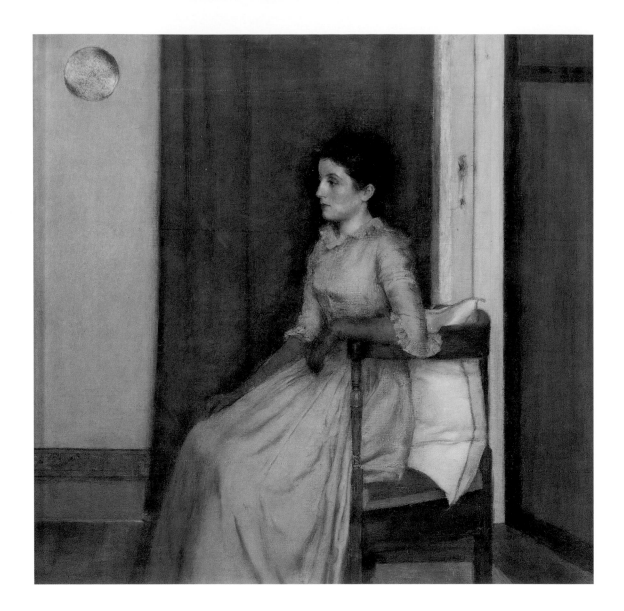

Figure 28
Fernand Khnopff,
*Portrait of Marie
Monnom*, 1887. Oil on
canvas, 49.5 × 50 cm
(19⅝ × 19⅝ in.).
Paris, Musée d'Orsay.
Photo: Erich Lessing /
Art Resource, New York.

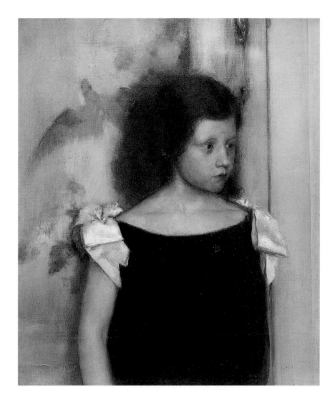

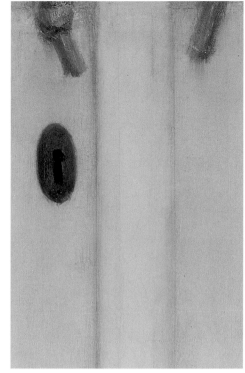

damental details that are not there by accident. This includes the keyhole [FIG-URE 30], a realistic detail that could have been removed without difficulty to focus attention on the model but that has been precisely drawn and carefully painted. When analyzed, this detail assumes a somewhat disproportionate importance. Khnopff insists on this motif, repeating it regularly in his portraits. It appears in that of Marie Monnom [FIGURE 28], where Khnopff has drawn a curtain across the studio door, taking care, however, to stop at the keyhole, which thus becomes a focus of attention. Ought we to assign a particular significance to the obsessive presence of this keyhole, or see it purely as a simple ornamental caprice? Although little is gratuitous in Khnopff's work, the question remains. Ought we to deduce the painter's conception of his model from this element, with its strong Freudian overtones? Associated with the analogy between the woman and the door, does this motif permit us to enter the byways of psychoanalysis? The answer probably lies in the ensemble of themes Khnopff developed during his life. The keyhole introduces an element of locking up or cloistering that highlights the isolation of the figure. Experienced here in narrative mode, it will become a commonplace of Khnopff's Symbolist iconog-

Figure 29
Fernand Khnopff, *Portrait of Gabrielle Braun*, 1886. Oil on canvas, 31.5 × 26.5 cm (12⅜ × 10⅜ in.). Brussels, Crédit Communal de Belgique, 1501.

Figure 30
Fernand Khnopff, *Portrait of Jeanne Kéfer* [Figure 1]. Detail of the keyhole.

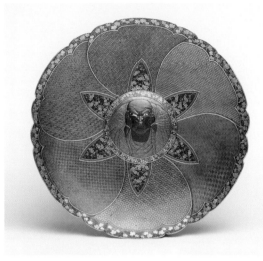

raphy in the form of silence, in *Silence* (1890),[59] and of interior retreat, in *I Lock My Door upon Myself* (1891),[60] or of an ebbing back into ideality and its mysteries, in *Verhaeren: An Angel* (1889).[61] This narrative act of closing off is also a plastic principle that defines the very idea of representation. The relationship of the figure to the pictorial field, of the picture to the frame, and of the painting as an enclosed object to the hanging rail will, in the same way, be determined by this concept of isolation.

Onto the keyhole theme, still clearly legible in the portrait of Marguerite Khnopff, the artist overlaid another decorative motif, presented for the first time in Marie Monnom's portrait [FIGURE 31], to her left. Whistlerian in inspiration (it appears to the left of Cecily Alexander in FIGURE 24), it acts as both emblem and sign, as signature and symbol. The object appears very real in Khnopff's work. It is a late-nineteenth-century metal Japanese serving bowl with copper and silver incrustations, decorated with plant motifs [FIGURE 32]. Similar to those found in London's Victoria and Albert Museum,[62] the bowl adorned Khnopff's studio wall. Its circular shape refers to the theme of the mirror often employed by Khnopff as well as to the tondo shape that he frequently used either as a format or to define the framing of an image [FIGURE 33]. In this way the circle circumscribes an enclosed perfection echoed by various details expertly placed in the composition. This seal is to be found, enigmatically, on the wall behind Germaine Wiener in Khnopff's 1893 portrait of her [FIGURE 34]. A metaphoric signature, it also acts as an esoteric symbol whose meaning remains enigmatic.

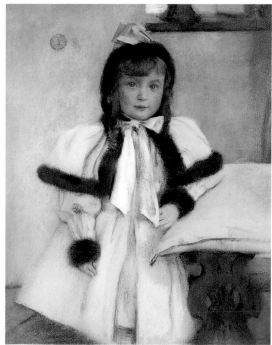

The analogy governing the relationship of the subject to place is paralleled by the analogy that organizes the symbolic reading of the details that, scattered across the composition, question the viewer's gaze. To portraiture's traditional emblems, Khnopff adds motifs that invest the place with a particular meaning. The image functions as a series of divisions that underscore the hermetic nature of the image at first glance.

THE SEARCH FOR A FACE

From Mademoiselle Van der Hecht to Jeanne Kéfer, the depiction of the child in Khnopff's oeuvre has evolved decisively. The artist has redirected the representation inherent in the portrait painter's practice in terms that reveal a close proximity to Whistler's approach in his portrait of Cecily Alexander. While turning the model into a tool for constructing his own "arrangement," Khnopff retains the model's ability to resist the act of representation. Before staging the portrait by merging a place and a being in the theatrical privacy of the studio, the painter concentrated on the individual he was required to

Figure 33
Fernand Khnopff,
Study for "The Secret,"
ca. 1902. Pastel and
charcoal on paper,
Diam: 30 cm (11¾ in.).
Private collection.

Figure 34
Fernand Khnopff,
*Portrait of Germaine
Wiener*, ca. 1893.
Oil on wood, 50 ×
40 cm (19⅝ × 15¾ in.).
Brussels, Musées
royaux des Beaux-Arts
de Belgique, 10.948.
Photo: Speltdorn.

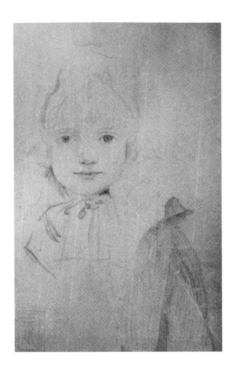

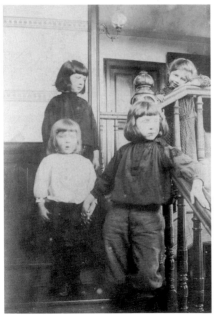

portray. A sketchbook page, now lost, offers a preparatory stage of the composition [FIGURE 35]. Here Khnopff has represented only Jeanne Kéfer's face. True to his method, he has taken a close-up approach to set down the little girl's features with surgical precision. As in many of his portraits, this first stage constitutes a very special moment. Abolishing distance, Khnopff gives us a portrait that directly reflects reality as it presents itself to him. Even so, this drawing already hints at the orientation of the final portrait. Khnopff leaves vague the ornaments surrounding the oval of the face, responding to the arrangement of the portrait. The bonnet, the hair, and the bow envelop the eyes and the mouth — the features that, in their essence, define being. Comparison with the painted portrait emphasizes the Realist dimension of the preparatory drawing. The face appears squarer and less perfect than the porcelain icon that would come later.

In the absence of archival documents, it is impossible to be more precise as to the relationship between the portrait and its model. We can at best turn to other comparisons. For example, in a preparatory photograph [FIGURE 36] for the *Portrait of Monsieur Nève's Children* [FIGURE 37], the children's faces are not as refined as they appear in the painting. Compared with items from the painter's photographic archives [FIGURE 38], the many paintings of his sister Marguerite reveal the same disparity.

The preparatory drawing of Jeanne [FIGURE 35] closely examines the child's features. The artist fixes on paper a fragment of reality perceived with a photographic immediacy, including positioning the face off-center as if insisting on the framing automatically performed by the painter's eye. From the drawing to the painting, the model becomes increasingly idealized as the mask concealing the real Jeanne takes shape: the features become finer, the face rounder, the lips narrower, the eyelids lighter, and the gaze itself intensifies. As Whistler had already indicated, the child no longer belongs to itself: it is now part of an exclusively pictorial

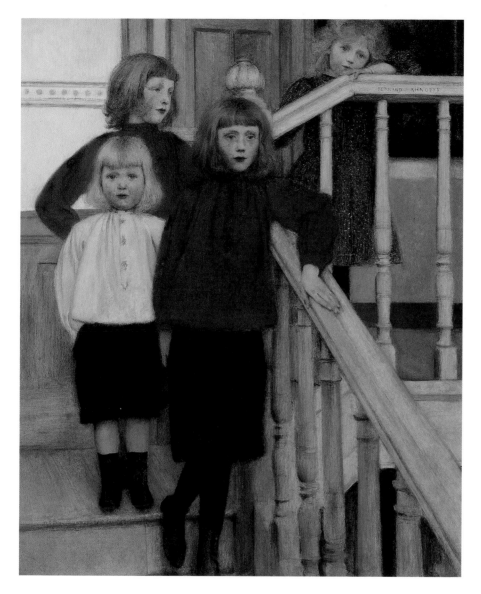

opposite, top
Figure 35
Fernand Khnopff, *Study
for the "Portrait of
Jeanne Kéfer,"* 1885.
Pencil on paper, 20 ×
13 cm (7⅞ × 5⅛ in.).
Location unknown.
Reproduced from R. L.
Delevoy, C. de Croës,
and G. Ollinger-Zinque,
Fernand Khnopff,
2nd ed. (Brussels,
1987), p. 231, no. 81.

opposite, bottom
Figure 36
Photograph Used for
the *Portrait of Monsieur
Nève's Children,*
1893. Private collection.

Figure 37
Fernand Khnopff,
*Portrait of Monsieur
Nève's Children,* 1893.
Oil on wood, 49.5 ×
40 cm (19½ × 15¾ in.).
A handwritten note
in the margin gives the
names of the models,
stating that they
have been grouped
following the sketch of
Khnopff's painting.
Private collection.

logic to which it opposes the fundamental resistance that made Cecily Alexander [FIGURE 24] glum and sulky.

Khnopff does not follow the anecdotal path that corresponds more to the author of *The Gentle Art of Making Enemies*—James McNeill Whistler—than to his sense of extreme reserves. The idea of isolation participates in the painter's

41

very method. The move from drawing to theatricalized composition is based on a symbolic distancing. Graphically recomposed, the face has encountered the type and isolates itself from any context. Idealized, it belongs to another space: that of the image.

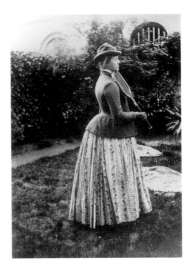

A PHOTOGRAPHIC ICON

Removed from reality and having become a mask, Jeanne's face slides into an architecture of off-center horizontal and vertical lines that define the focal point of the composition [FIGURE 1]. The layout uses a distancing principle that inevitably evokes photography. Has Khnopff used this medium here? Quite probably. The press of the time was quick to allude to the possibility. In his account of the salon of Les XX, Georges Verdavaine describes the portrait of Jeanne Kéfer: "Place yourself in the right light and look at this little girl with her flaming blond hair and large, surprised eyes who seems to be standing in a door waiting for the photographer to arrive with his camera."[63]

This relationship with photography[64] constitutes a vital element in Khnopff's method. The catalogue of the studio sale that took place on November 27, 1922, a few months after the painter's death, informs us that the dispersed objects included a Steinheil camera with a tripod, six double frames, and all the necessary paraphernalia.[65] What was this high-quality apparatus intended for? The archives inherited from Khnopff himself[66] contain a series of forty-four photographs that, from 1889 to about 1902, served as models for Symbolist compositions, such as *Memories* [FIGURES 38, 39] and *The Secret*. A few

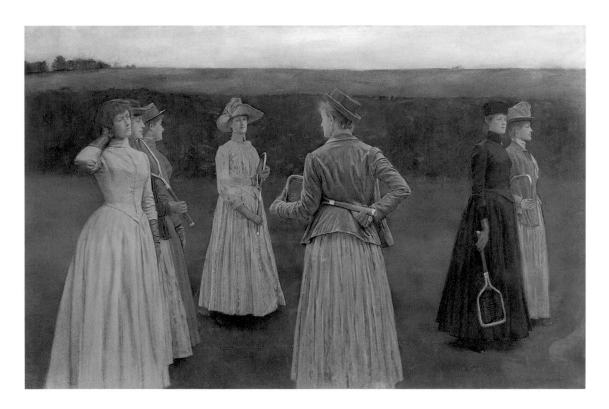

Figure 39
Fernand Khnopff, *Lawn Tennis* or *Memories*, 1889. Pastel on canvas-backed paper, 127 × 200 cm (50 × 78¾ in.). Brussels, Musées royaux des Beaux-Arts de Belgique, 3528. Photo: Speltdorn.

photographic prints have also been preserved by the patrons of his portraits. Academic painters, including Jan van Beers in Brussels and Franz Lenbach[67] in Munich, did not emply photography as a tool in commercial portrait painting, and the practice was, moreover, the butt of severe criticism in the press. However, Khnopff, who kept his distance from both critics and the outside world, favored its use in portrait painting. Avoiding thereby the proximity inherent in long sittings, the painter discovered in photography a medium through which to question reality: inscribed in the instant, photography offers an objective rendition. As if turned into stone, life is immobilized into a drawing that the act of painting will render final.

By its mechanical nature, the photograph allowed the painter to place an intermediate stage between the model and the final image that fixed the pose, provided a preliminary underdrawing, established the setting, and imposed distance. It seems that the preparatory drawing takes place at this essential stage of the creative process, adhering to reality without questioning the representation. Starting with a photograph, Khnopff was able to come closer to his model without questioning the principle of otherness, which remained,

in his eyes, central to the portrait. In the close-up linking of the drawing to its photographic support, Khnopff scrutinized his model.

The instantaneously caught photograph is then reworked, developed, and scraped bare until the final image emerges. Under cover of its imitative perfection, the photograph eliminates the fastidious exercise of reproduction in favor of an image conceived from the outset as "the impression of a memory." A mirror of reality fixed at the surface of the paper, the photograph becomes memory, proving the existence of what once was. But this image is not an end in itself. In the painter's eyes, it is no more than a tool in service to metamorphosis, just as the recollection of someone exists only through the action of the faculty of memory.[68] This faculty defines the value that Khnopff assigned to the drawing. The sought-for mimicry finds in the photograph a model whose ambiguity creates meaning: a vestige of the past, it is no less indisputably present.

Khnopff's large painting Memories [FIGURE 39] is very likely where the artist reveals with greatest force the symbolic value he assigned to photography. Here the image is made up of a to-and-fro movement, from fragments of petrified reality captured by the photographic "eye" to their dreamlike metamorphosis under the alchemical action of the drawing. This fills out the original outline fixed by the action of the light and deploys those sensations that the action of memory favors. The relationship uniting the drawing to the photograph justifies the work's title as much as does the "abstract" composition of these seven simultaneous portraits of his sister in different, if not conflicting, clothes and points in time. In this Recherche du temps perdu—like the one later undertaken by Marcel Proust—the act of writing that drawing induces alone seems able to reorganize the fuzzy past.

The academic doctrine of the "happy medium" (juste milieu) had found in photography the special place where drawing happens in an epiphanal movement—in the physical sense of the term—leading naturally to the capturing of the iconic dimension of the image. Important though it is, however, the photograph remains no more than a tool. By using it, Khnopff has himself disputed the validity of the statement that "since photography furnishes us with every desired guarantee of exactness . . . , art is photography."[69] Like Lady Elizabeth Eastlake in 1857 and Charles Baudelaire two years later, Khnopff valued technical innovation simply for its utilitarian function, which freed the painter from the servile tasks inherent in the exercise of representation. As Eastlake—the wife of the director of London's National Gallery—had pointed out, photography is unable to touch "this mystery known as Art, in the elucidation of which photography can provide precious assistance simply by show-

ing what it is not."[70] In 1898 Khnopff took up the argument at a symposium he participated in with Robert de La Sizeranne, Alfred Lys Baldry, Henry Peach Robinson, and G. A. Storey, organized in London by the *Magazine of Art*.[71]

For Khnopff, photography, however much it formally shares the same ideal as painting—"the representation of nature with the largest possible N"[72]— cannot be confused with the aspiration to transcendence inherent in artistic creation. The camera lens is unable to travel the path that the artist does, which, creating a crisis in the act of looking, transforms outward reality. Relaying in this way the ideas of De La Sizeranne that had appeared in the *Revue des Deux-Mondes* in 1897 and been picked up at the opening of the 1898 symposium, the painter recognized photography as having only three freedoms: choice of subject, choice of framing, and choice of printing.

For Khnopff, "the photographer's intervention goes no further than immobilizing his models in *tableau vivant* poses."[73] These *tableaux vivants* were aimed at abolishing the distance that, whatever the degree of illusionism in the work, separates any image from reality. Blurring the limits of representation, the *tableau vivant* seeks to be both painting (tableau)—that is to say, the representation of a small part of reality from which it remains at a distance—and life itself in its innate irreproducibility [FIGURES 40, 41]. The *Portrait of Jeanne Kéfer* is moving toward this ambiguity, which Khnopff elevates to a poetic form.

The reference to the practice of the *tableau vivant*, current at the time,[74] testifies to the "marker" role attributed to photography. Its task is to fix, forever, a single, staged moment of time in its smallest details. The importance Khnopff attaches to framing is explained by this need for a theaterlike staging, which defines the image by distancing it from reality. Instantaneity captures not a process but a technical reality. The staging that precedes the taking of the photograph places the usefulness of photography very clearly on the side of the idea and the "arrangement."

The last freedom is that of manipulating the image as a chemical process. Here the photographer can disturb the lights and shades, blur their relationships, destroy the modeling, render the entire effect heavier. This is clearly proved by the proofs both before and after the bichromate gum process that certain manipulators have furiously or gloriously exposed.[75] But Khnopff is quick to limit the artist's field of action: "Even the most skillful photographer will attempt in vain, will never succeed in dominating the shape and the light imposed on him by his model."[76] Relegated to the same level as the engraver, the photographer cannot, therefore, claim a freedom of expression.

If Khnopff confines photography to Realism, "with its superficial aspects of life in action,"[77] he does not condemn it. First of all, he acknowl-

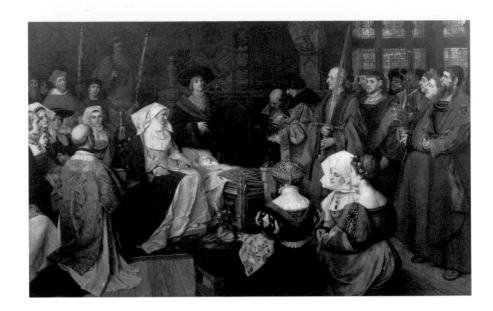

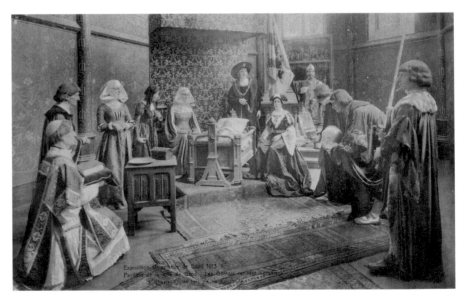

edges that it has a documentary value that goes farther than the simple surface appearance. Indeed, the photographs taken by Khnopff (or under his guidance, as he states that he understands none of the technological process himself) testify to a capacity for staging that profoundly renews the painter's vocabulary with its dynamic layout. It is true that Khnopff did not think of the prints as

works of art in themselves. They nonetheless remain of supreme importance in fixing the idea, *immobilizing* the subject in a radically new image. As illustrated by the *Portrait of Mademoiselle van der Hecht* [FIGURE 19], which reveals another type of relationship to the model, photographic vision transforms the traditional structures of the painted portrait.

In making photography a tool that is for him neither the last resource nor a crutch for a poor hand or eye, Khnopff has drawn from it a new freedom of invention. The dynamism of the framing, the intelligent cutting and pasting to form a collage testify to a photographic desire: Khnopff has pushed Jeanne Kéfer back against this background, where, *immobilized*, she is delivered to the gaze of the lens. She does not pose for the painter in numerous, tiring sittings but briefly interrupts her life to pose for the photographer, who has focused his lens on the child's face, leaving vague everything behind or reflected in the glass. Khnopff does not lie: in his painting he is not seeking the illusion of a posing session with its staging, its requirements for plasticity, and its pictorial references so dear to Whistler. He "cheats" with respect to the illusion of spontaneity produced by the photographic act: the taking of the photograph is itself a construction—a *tableau vivant*—that obeys a staging charged with references that culminate in an "arrangement."

The way that Khnopff views photography, therefore, is not lacking in modernity. He emphasizes and exploits the smallest departures from the mimetic principle to which the photographic act had been too quickly reduced. In fact, the limitations inherent in photography that Khnopff exposes —the arbitrary nature of fixed monocular vision and the distance that places the observer outside the spectacle offered to the camera lens; the framing that immediately directs the meaning of the representation; the reduction of sensations to the visual presence alone; the trompe l'oeil that summarizes three dimensions in two; and, finally, the reduction of the palette to a dialogue that, between black and white, reduces the various shades of gray into a tone of sentiment charged with melancholy—serve to support the artist's questioning of representation in his landscapes, still lifes, and portraits. Being mimetic, the photograph takes advantage of the rules of perspective to better reveal the artificiality of the image conceived as an icon.[78] Khnopff recognizes photography as possessing a quality based on this simple effect of artifice that delivers up only the "marker" of reality, with the simplicity and banality of what is judged to be a "middling" art.[79]

In this context the portrait enjoys a singular status that enables us to place Khnopff at the heart of a growing practice at the end of the nineteenth century. By making long posing sessions unnecessary, the photograph reduces

the artist's relationship to the subject to a mechanical act producing no more than a surface effect on a thin film. Developed chemically, the photographed body becomes a mask. In the place where Khnopff can construct the type by recomposing a fragmented ideality—a specific mouth joined to a certain forehead, associated with a particular set of eyes, and so forth—photography remains dependent on the hazards of the moment, on the "truth" of the model, and on the object's ability to speak. It renders conditional the artist's absolute mastery of the act of creation. Khnopff seems to savor this instant that focuses the eye on a reflection, behind which an inner life exists.

On the one hand, the photographic reference conceals deep reality under the thin surface of appearance. On the other hand, it allows the painter to grasp this reflection and to give it a new aura. Functioning like a preparatory drawing—a "photogenetic drawing" (*dessin photogénique*)—photography fixes the *tableau vivant* from which the painter can deploy his imaginary vision. In this way, Monsieur Nève's children have been photographed not as they happened to be positioned at a particular moment but according to a staging preestablished by Khnopff [see FIGURES 36, 37]. The handwritten note at the bottom of the photograph seems to confirm this. Like Marguerite posing for *Memories*, they have taken up the positions that the painter has dictated. The photograph is therefore not the objective reflection of a *natural* instant, but the conclusion of a process of *thought-out* construction that makes each participant the actor in a scene that has already been played out in the artist's mind. While allowing the artist to develop his work without having to worry about his models, photography has also provided him with a medium of reflection that is no longer reality, but already an image. Imperceptibly, the model leaves real time and space and enters the imaginary world of the painter, who takes hold of the model's features and body: mouths close, features become purer, and faces are more refined until they correspond to Khnopff's ideal typology.

A PHOTOGRAPHIC EYE

In his two essays, published nearly twenty years apart (1898 and 1916), Khnopff betrayed scant interest in the photographic act of seeing, although for him this was a topic of major concern. If he spent so little time on the subject, it is because the singular nature of this form of seeing contradicts the reservations he repeated between 1898 and 1916. Subject, framing, and printing were no more than secondary aspects; Khnopff denied the value of photography as art [FIGURE 42]. He believed, however, that the actual pho-

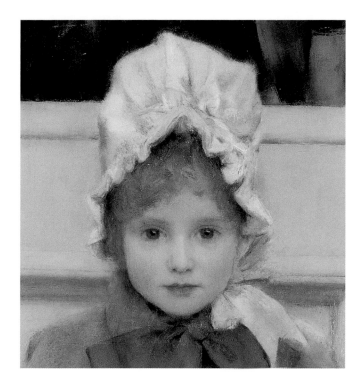 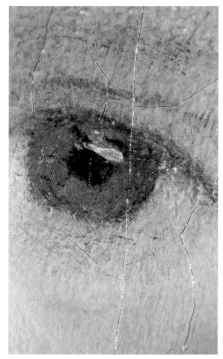

tographic act of seeing [FIGURE 43] constituted the very originality of the photographic image and, through it, of the painted portrait. A convenient tool, photography also reveals much more than a simple reflection. It delivers up a singular presence that Roland Barthes would later refer to as the *punctum*—understood as the point that fixes and immobilizes me when I look, and that transforms forever my reading of the image. The detail that "jumps" at the eye attacks, gathers to itself, and upsets the meaning without necessarily making sense.[82]

As early as 1857, Lady Eastlake had emphasized this "force of identity" that the detail—a buckled shoe or a negligently held toy—confers on the model. This *punctum* detracts from what the portrait intends in order to present something to our view. Disengaged from its ornamental function, freed from its submission to the subject, the minor detail reveals more than convention intended.[83] It becomes something inexpressible that the painter plays with in the portrait. This detail is very much present in the portrait of Jeanne Kéfer: the thumb pinching the brown bow of the coat and the black knots of the shoes question the eye and, by forcing it to concentrate on details, blur the general obviousness of this "simple" portrait.

Figure 42
Fernand Khnopff,
Portrait of Jeanne Kéfer
[Figure 1]. Detail
of Jeanne Kéfer's face.

Figure 43
Fernand Khnopff,
Portrait of Jeanne Kéfer
[Figure 1]. Detail
of Jeanne Kéfer's eye.
Microphotograph,
JPGM Paintings Conser-
vation Department.

In the context of the history of photography, which Khnopff is more a part of than he would have cared to admit, this work should be seen with reference to the British culture to which the artist was, as we know, very sensitive. From William Henry Fox Talbot to Thomas Hardy, and not forgetting Lewis Carroll, British culture exalted the phantasmagoric openness of photography that, metaphorically, allowed them to question the principle of creativity. Although in his writings he distanced himself from this practice, Khnopff in fact participated fully in the desire to analyze the reality seen, which, once on paper and fixed as an image, lent itself to visual analysis and explanation. In photography, this phenomenon unfolded as "games of writing which saturate the realistic image with imaginary additions."[82] In this way, photography was transformed into an enigma that Talbot's "photogenetic drawings" already celebrated as "magic."[83]

Khnopff also appears dependent on another feature of the relationship of British culture with photography, that of possession. As early as 1830, before starting his technical research, Talbot had raised the question in a poem entitled "The Magic Mirror." In this vampirelike transfer from oneself to the other, the mirror induces a feeling of possession that would in part determine the way photography, and in particular the photographic portrait, was seen and understood.[84] In the case of *Jeanne Kéfer* [FIGURE 1], this sensation of possession is achieved by the methodical work of the painter, who, step by step, moves away from the reality reflected by the photograph without ever renouncing his mastery of this original act of seizure. The paintbrush takes over from the camera lens, metamorphosing an anecdotal pose into a philosophical meditation on the otherness embodied by this child imprisoned in a pictorial space.

The association of the mirror with photography involves the elimination of the photographer as intermediary. Talbot's theses concur with this, reducing photography to a "natural" mechanism governed by the sun. In this process, the suspension of time gives the object an opportunity to "trace its own outline without the help of the artist's pencil,"[85] in the same way that the face lightly touches the surface of a mirror. We will see that, in Khnopff's case, this conception ties in with his fascination with the painting of the Flemish primitives, with its smooth surfaces and glazes that allow the light to deploy itself from the depths of the image as if it were no more than a reflection imprisoned in the mirror.

In a small self-portrait dating from 1882, Khnopff already had experience with this photographic act of seeing that is at work in the *Portrait of Jeanne Kéfer*. It shows him looking at himself in the mirror with a fixed eye, an eye like the one that, through the camera lens, metaphorically seizes hold of

reality. This parallel is far from irrelevant in the case of
Khnopff, who returned regularly to this mirror motif.

In 1889 *With Grégoire Le Roy: My Heart Cries for the Past*
[FIGURE 44] stages this notion in its plural dimension.
This theme is present in the constitution of the "me" in the
reflection, leading it astray down narcissistic avenues, con-
firming the engulfing power of the principle of image.
The mirror is one anchoring point of the virtual the-
ater that Khnopff stages. It turns into a screen when the
eye projects onto it the reflection of its exterior, and it
becomes porous when memory invests it with sullen
melancholy. For Khnopff the mirror is not limited to the
surface effect, as can be seen in the variants of *My Heart
Cries for the Past*. On the one hand, the woman seeks to fuse
with her reflection, affirming the unity of two opposing
realities. On the other hand, the image set in the frame
tends to abolish its own outline to restore the faded sen-
sation. The spatial unity that is renewed through the nar-
cissistic kiss restores the links binding the past to the
present. As instantaneous as a photograph, the image born
on the mirror's surface retains its psychological depth.
While paying attention to the latter, Khnopff could not
remain insensitive to the former.

The *Portrait of Jeanne Kéfer* is witness to Khnopff's
reflection on the act of photography. It may even have been
the laboratory in which this reflection was carried out,
with the painter seeking to move away from a modernist
reading shackled to Realist aesthetics, with their material
effects and lyric gestures. Following this reading, Khnopff
used photography precisely to rediscover the deep mean-
ing of painting.

Figure 44
Fernand Khnopff,
*With Grégoire Le Roy:
My Heart Cries for the
Past*, 1889. Pencil,
color crayons, and white
chalk on gray-blue
paper, 25.5 × 14.5 cm
(10 × 5¾ in.). New York,
The Hearn Family Trust.

A CODED SCRIPT

Between the simple representation of the model and
the engulfing effect of the image, Khnopff also plays
with photographic references. Child portraiture rapidly be-
came a specialty of modern photography [FIGURE 45].[86]

Figure 45
Postcard, early
twentieth century.
Reproduced with the
kind assistance of
Messrs. Couvreur and
Smyers.

The staging of the *Portrait of Jeanne Kéfer* reflects the demands of a rapidly expanding photographic industry. A plaything for the leisured classes, the practice also found real masters in Lewis Carroll and Julia Margaret Cameron. While not necessarily sharing their vision of childhood,[87] Khnopff is nonetheless interested in their conceptions of the image.

Khnopff has retained the originality of Carroll's framing as well as his emphasis on the chemical reality of the photographic image, which reveals itself in slow degrees. Khnopff makes painting an equivalent of Carroll's "black art."[88] Like Carroll, Khnopff uses a dynamic framing that testifies to a magical relationship with reality. This includes the stripping of setting and a symbolic use of accessories. Several of Carroll's photographs can be shown to parallel Khnopff's paintings [FIGURES 46, 47]. Both Khnopff and Carroll make the image — photogenetic drawing for the first, photographic theater

Figure 46
Lewis Carroll (Charles
Dodgson; English,
1832–1898), *Alice
Liddell Lying on a Sofa*,
Summer 1858.
Albumen print. Photo
courtesy Sotheby's
Picture Library, London.

Figure 47
Fernand Khnopff,
In Summer, 1889.
Oil on wood,
24 × 31 cm
(9½ × 12¼ in.).
Private collection.

 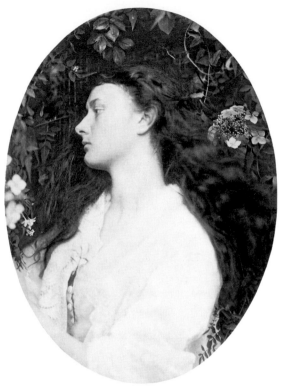

Figure 48
Lewis Carroll, *A Scandinavian Xie*, 1873.
Reproduced from
Morton N. Cohen,
Reflections in a Looking Glass: A Centennial Celebration of Lewis Carroll, Photographer
(New York, 1998), p. 70.

Figure 49
Julia Margaret Cameron
(English, 1815–1879),
[Alethea] Alice Liddell,
[1872]. Albumen print,
32.5 × 23.7 cm (12 ¹³⁄₁₆
× 9 ⁵⁄₁₆ in.). Los Angeles,
J. Paul Getty Museum,
84.XM.443.18.

for the second—into a "philosophical tool"[89] that operates the way a mirror does. The same relationship to the *tableau vivant* passes naturally from the painter to the photographer. Like Carroll, Khnopff wants his figures to have this graphic elegance—an attractive design—and he prefers full-length portraits and expressive effects.[90]

Khnopff also aspires to express the innocence of the subject [FIGURE 48]. The reference is not to bourgeois conventions, however, but to those inherent in the representation. Whereas in Carroll's work this immediacy of the bared subject is based in photographic phantasmagoria, in the case of Khnopff it calls for an exercise of decoding that takes the viewer beyond the mask of appearances. For Carroll, the prisoner of Victorian puritanism, innocence is the product of an imaginary elsewhere. For Khnopff, it consists of an interior experience deriving from and depending on the relationship binding the painter to the model, and the subject of the painting to the painting itself.

Khnopff shares this primacy of the image in its plastic sensibility with Julia Margaret Cameron. She conferred on photography a psychic dimension that made the image the reflection of a sensation. The treatment of the surface

plays a less important role here than the decoding, which, under the exterior form, allows existence to rise to the surface. For Cameron, the photographer—like the painter—should seek to seize the inner workings of the soul [FIGURE 49]. Breaking the unity of the surface, Cameron rejects the finite that is traditionally shackled to the objectivity of the photographic rendering. Cameron photographs her subject close-up, combining a wide aperture with low levels of light.[91] Through its quivering, "tremolo" effect, the image ties the tactile quality of the close view to the "uncertainty" endemic to the experience of the senses. Far from an ideality reduced to conceptualized form, Cameron's approach meets the need to see the model up close, with a proximity that restores the immediacy of the sensation. Khnopff retains only a few of these quivering effects, which invest the act of looking with a desire to touch: the vagueness of the little girl's hair, the vaporous sensation of the flesh, and the partial effacement of the outline testify to the same sensuality.

But after this, Cameron, like Khnopff, is careful to distance herself from this "instinctive act of looking." The meaning she is seeking is the final outcome of a work of purification and staging, with the sense of touch giving way to the theatricality of the pose. The uncertainty of the contour is "corrected" as the image becomes more distant and the play of light composes its own rhetoric. Khnopff would follow the same path. In this way, in *Memories* [see FIGURE 39], each player has her own role and each gesture becomes the paradigm of a story revealed by the light. The relationship entered into with each individual instant of this unique model is recomposed in the unity of the construction.

From Cameron, Khnopff has preserved the melancholy of a pose that escapes into memory, imparting to the image the loss of tautness characteristic of works of the imagination [FIGURE 50]. The portrait gives way to a face minus the relationship to the model still being experienced as an obligation. From the *Portrait of Jeanne Kéfer* to *Arum Lily* [see FIGURE 76], the same face evolves from reality to dream, from work based on a model to fantasy.

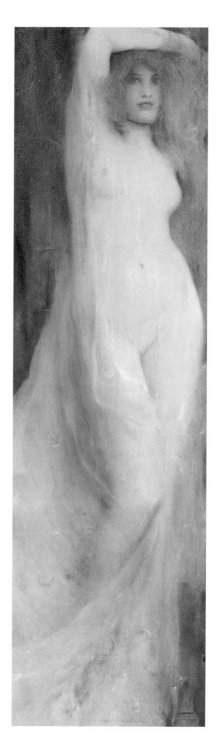

Disqualified from the realm of art in terms of mental construction, pho-
tography — reduced to an industrial process — was also criticized from
the viewpoint of handling. In an article published by *L'Art Moderne* in 1881, an
anonymous critic complains, for example, of the lack of any trace of the artist's
hand—and hence the absence of genius— in photography. It is the presence of
this hand, the "interpreter of the soul,"[92] that is seen as guaranteeing a unique
presence that the camera wipes out. The theme of the natural image is accom-
panied, as we have seen, by the obliteration of the photographer to achieve
an act that is seen as objective for being spontaneous. The argument radically
opposes the smooth, mechanized texture of the photograph to the lyrical,
matter-based handling in a painting. It is the movement of the artist's hand—
sweeping, free, and anchored in matter—that alone guarantees the artist's
presence. In this way, in the *Portrait of Jeanne Kéfer*, the motif of the pane of glass
takes on a personal quality, making this portrait within a portrait into a signa-
ture that repeats the one incised at the bottom of the canvas [see FIGURES 23,
24]. The latter names; the former designates.

The question of handling returns us once again to photography. The
condemnation of photography as a strictly technical process places on trial
both the practice of copying and the idea of representation as lacking any
temperament. The fact is that this lyricism, which animates the sentence or
passes through the brush, undermines the Naturalist approach.[93] The criti-
cism expressed in *L'Art Moderne*, which sees photography as a series of tech-
nical processes that "diminish life, . . . cause the personality to vanish, [and]
deprive the work of its psychological substance,"[96] is transformed into argu-
ments in favor of the authenticity of the Naturalist image.

For Khnopff, the impersonal character of the photographic drawing
is a spiritual requirement, of which the *Portrait of Jeanne Kéfer* is one of the first
results. Reflecting reality, the image speaks an unknown language that it is our
task to decipher without losing touch with what has been depicted. The
mimetic illusion constitutes an imperative: that of allowing nature to "print
itself" onto the canvas, where it can be decoded, understood, and recom-
posed into something beyond what is accidental and that corresponds to the
project that the painter has developed in his mind [FIGURE 51]. A portrait
should therefore tend toward perfect mimetic illusion, the better to emphasize
the distances separating the final image from the model, who is subject to reality.

This conception of photography is rooted in a philosophy of painting
that Khnopff was constantly exploring. In this way the "photogenetic drawing"

overleaf
Figure 50
Fernand Khnopff,
*Acrasia: The Faerie
Queen*, 1892. Oil on
canvas, 150.8 ×
45 cm (59 ⅜ × 17 ¾ in.).
Anne-Marie Gillion
Crowet Collection.

responds to the engraver's incision into the copperplate. The latter produces a sharp line that causes the white of the paper to vibrate. The former dissolves the line into a luminous continuity that ignores the vacuum [FIGURE 52]. In its transparency the latter tends toward narrative in the deployment of the artist's hand. In its density it delivers itself as a unique presence. The portrait expresses this constant to-and-fro with subtlety, retaining from the preparatory drawing only a few strokes that define the subject and position the composition. From the solar apparition delivered by photography, Khnopff has retained the indescribable movement of light, the informal fluidity of hair.

For Khnopff, the "eloquence of art" invoked by the critic for *L'Art Moderne* lies neither in tormented brushstrokes nor in paint handling that injects the artist's subjectivity into the depicted colors and shapes. Rather, the work of the hand consists of a methodical exercise of decoding, which produces a work that is at once clear and symbolic, binding in a single perspective modern photography and the paintings of the Flemish primitives.

Right from his first appearance on the Brussels artistic scene, Khnopff was described as a "modern-day Memling."[95] Compared to the minia-turists, the epithet of "Gothic" applied to his work points to a new view of the Flemish identity as something less Rubensian and realist, and more symbolic and "primitive" [FIGURE 53].[96] Writing of the female face Khnopff exhibited at the 1883 L'Essor Salon, the critic for *La Jeune Belgique* drew his readers' attention to the parallel: "[Khnopff] appears to seek to renew, by modernizing it, the art of the primitives. From them he has already taken that self-confident line and that meticulous touch in which the value of his works lies."[97] The reference to Gothic is all the more insistent given that the fifteenth-century Flemish primitives were just then being rediscovered, marked by a Romantic desire to move away from classicism. The movement paralleled that of the contemporary English Pre-Raphaelites, who were themselves fascinated by Hans Memling's emblematic personality. It was Memling in particular who caught the public's attention. Perception of his work was veiled

Figure 51
Fernand Khnopff,
Portrait of Jeanne Kéfer
[Figure 1]. Detail
of the layers of glazes
on the girl's thumb.

Figure 52
Fernand Khnopff,
*Portrait of Jeanne
Kéfer* [Figure 1].
Detail revealing
the underlying drawing.

Micrographs, JPGM
Paintings Conservation
Department.

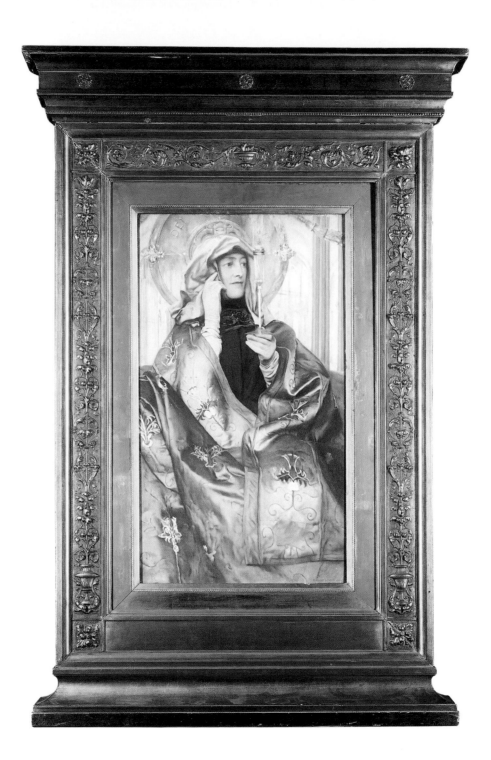

in sentimentalism: in him was seen the expression of a "sense of devotion, of ideal purity in which Romantic *Sehnsucht* recognizes a lost naiveté."[98] The artist's persona is closely associated with the Hospital of Saint John,[99] where he spent a large part of his life and where he created some of his masterpieces. Khnopff later portrayed these works in a series of drawings linked to his reading of *Bruges la Mort*, Georges Rodenbach's Symbolist novel (1892).

Far from rejecting the flattering comparison with Memling, Khnopff paid him his due in December 1893 by presenting lectures to the Arts Section of the Maison du Peuple on his concept of the Flemish Gothic painters, Jan van Eyck, Quentin Metsys, and Hans Memling in particular. Unfortunately, the text of these lectures is lost. In all likelihood the painter evoked his admiration for the precision of detail, the crystalline purity of the drawing, and the "precious execution"[100] of those jewels imprinted with mysticism, which led him to study and draw inspiration from several of Memling's figures.[101]

Khnopff's interest in the early Flemish painters should be seen as part of a vast movement of rediscovery that began in the 1850s, when the Antwerp painter Henri Leys[102] sketched out a definition of a Flemish sensibility, passing no longer through Rubens and the variegated patterns of the Baroque brush but through the internalization of a tight handling close to the academic sense of "finish." In this way the movement begun in Belgium joins the one that, in England, led contemporaneously to the creation of the Pre-Raphaelite Brotherhood.

In 1871 the publication of William Henry James Wheale's book on Memling called for an initial revision of the artist's oeuvre, freed from Romantic mythology.[103] Alongside that of the English Pre-Raphaelites, the painting of the fifteenth-century Flemish primitives provided the basis for reflection on the image and its codification. Conditioned by the photographic objectivity then at the heart of the debate, the reference to the early Flemish artists touches simultaneously on theory and practice. Saddened by the present, Symbolist artists, led by Khnopff, took refuge in the past that Rodenbach's *Bruges la Mort* (Dead Bruges) would later crystallize. From a technical viewpoint, the very illusionism of the fifteenth-century Flemish primitives defines a concept of the image that superimposes itself on the academic values of finish and precision of drawing.

Technique is a central element in this search for authenticity, which can be immediately seized with photography and for which Memling's painting was the pictorial reference. Photographic mimesis opens up new perspectives, which the *Portrait of Jeanne Kéfer* records. The painting presents itself as a vast "photogenetic drawing." On top of a white ground, with a light pencil,

Figure 53
Fernand Khnopff, *Incense*, 1898. Oil on canvas inside the altar frame designed by Khnopff, 86 × 50 cm (33⅞ × 19⅝ in.). Tokyo, Art Point, Inc.

59

Khnopff traced a particularly detailed compositional drawing. These details are not carried through in the subsequent stages, being present solely in this underdrawing, which remains visible. The drawing does not underlie the entire composition. Close examination shows that Khnopff concentrated only on the significant details — in the case of the child, the silhouette, eyes, and lips — and on the overall architecture. Having in this way defined the geometric positioning of his composition and the significant lines of his figure, Khnopff passes to the coloring stage. His limited palette makes reference to Whistler's harmonies: emerald and gray, as in the portrait of Cecily Alexander [FIGURE 24].

Compared with Whistler, Khnopff gives his "arrangement" a harmonic value that is apparent less in the unity of the colors than in the tonalities. The simplified palette tends toward white. The scientific analysis carried out by Mark Leonard, head of the Paintings Conservation Department of the J. Paul Getty Museum,[104] shows that Khnopff has unified the image visually by mixing his colors with lead white, thereby emphasizing this atmosphere of harmony, which passes from the model to the surrounding space as if both were made of the same substance [FIGURE 54]. This economy of means points to a desire to modulate in a minor key. Starting from the white, the effects are to be rendered by playing on the infinitesimal: the color of the little girl's coat, obtained by mixing pigments rich in iron oxide with the white. Playing on the concentration of the pigment, Khnopff renders the sensation of different materials with a succession of glazes. Without really changing his palette, and moving with perfect mastery from the pink of the bonnet to the brown of the coat, he contrasts the silk of the bows with the velvet of the coat, the hard gleam of the buttons, the rough mesh of the stockings, the polish of the shoes.

In 1886 the critics praised this technical mastery as giving the image the effect of a miniature. Virtuoso-like, Khnopff exploits the full range of his technical skills to render visually the tactile sensation of matter, reflecting, in doing so, one of the characteristics of fifteenth-century Flemish painting. In the paintings of Khnopff, as in those of Dieric Bouts or Memling, a tangible quiver can be sensed across the surface: it is his brush exalting subtle nuances by seizing or reflecting the light.

If his glazes enable the light to glow from inside the painting, with the painter's hand hidden behind the "natural" discourse of the material represented, the stockings are a different story [FIGURE 55]. Here, Khnopff plays as a vocalist. Here, too, he seeks to render the effect of the material. To do this, he abandons his smooth handling to play visually with the roughness of a scratched surface, revealing the lighter colored underlayers.

These effects of paint handling represent a tactile quality inherent in vision. The observer's gaze glides across the irregular, wavy finish of the surfaces, is absorbed by the velvet textures [FIGURE 56] and grazed by the rough paint. The technique depends on the desired effect. The representation of the glass pane interrupts the murmuring of this light scumbling in which the painter's gesture is dissolved. Here, without straying from the economy of his palette, Khnopff has remained faithful to the Realist lessons of his early days as a painter. The palette knife avoids Ensor's "ferocious trowelings," in which Camille Lemonnier saw, in 1880, the "blunt instrument of a manual worker,"[105] expressing less the density of the matter than the transience of the sensation. Khnopff remains frugal in his effects, content to disturb the still surface of the glazes as if the light, arising from outside, has broken the immutability of the reflection inscribed on the canvas.

The economy of the palette goes hand in hand with the very measured manual gesture that leads Khnopff to prefer tight brushwork. This aspect did not fail to strike the critics associated with the painter. As early as 1886, Verhaeren pointed to this singular technique:

Figure 56
Fernand Khnopff,
*Portrait of Jeanne
Kéfer* [Figure 1].
Detail of the velvet bow.

[Khnopff] scarcely moves, nor does he get excited. Meticulous, with brief little strokes and a scarcely worried slowness, his point, brush, or pencil scratches the panel or the paper. But his eye is extremely acute. We sense a cruel determination, we perceive in it a tense, implacable, and incessant observation of things. There is no movement of his hand that his thought has not determined or controlled. His hand does not hesitate, but there is no panache, no fury, rather, an evident reserve and prudence. No beautiful liberty of drawing, no strong, distinctive paint handling, rather, thin, ferretlike, strokes, decisive, but almost like handwriting.[106]

Verhaeren is careful to distinguish the painter's canvases from the academic "licked surfaces" with which Khnopff's work had been compared by certain unfavorable critics. Referring to the paintings shown at Les XX in 1886— which included the *Portrait of Jeanne Kéfer*—Lucien Solvay himself had described Khnopff's works as plagiarisms of the "photo-paintings"[107] of Jan van Beers [FIGURE 57].[108] This parallel was intentionally provocative. Solvay and Van Beers had crossed paths in the law courts four years earlier, the former accusing the latter of being incapable of painting without the support of photography. This accusation was aimed at discrediting a form of industrially produced painting that Solvay believed he was also encountering in Khnopff's work.

Figure 57
Jan van Beers (Belgian, 1852–1927), *Portrait of Sarah Bernhardt*, 1888. Oil on wood, 38 × 28 cm (15 × 11 in.). Brussels, Musées royaux des Beaux-Arts de Belgique, 3640.

Far from commercial practices that aspire to photographic finish, Khnopff drew inspiration from the early Flemish painters to distinguish himself from the "impetuous colorists" spawned by the Rubensian tradition. Patient and intense, he derived his technique from his own temperament, to the extent of making it into a moral imperative far removed from conventional academic portraiture. Verhaeren is our witness:

> His patient concentration detached itself daily from contingency and fact. The observed detail, the scene sketched livelily and gaily, the anecdotal and individual recital, were but the froth of the observation. The task was to tend as far as possible toward the definitive, the fruit of ardent reflection and higher will.[109]

ABSORPTION AND CONTEMPLATION

The rendering of matter testifies to a desire for sensorial confusion: seeing aspires to touching in a close-up that favors detail. Khnopff's portraits, described as "Gothic," maintain a relationship with the work of the fifteenth-century Flemish primitives that is not confined simply to the paint handling. The modern painter shares with them an extremely meticulous rendering that makes each detail into both an act of devotion and a question. Beyond the finish of the image, "hidden symbolism" constitutes the link between Khnopff and his fifteenth-century models. The same use of apparently naturalistic elements for symbolic ends produces a coded system of representation to which we shall return. Ambiguity unites them in the same desire to illuminate reality with meanings veiled by naturalistic appearance. "All reality carries meaning," Erwin Panofsky would write of Van Eyck.[110] The perfection of the rendering guarantees the full legibility of the elements that make up the image. Khnopff does not limit himself to reproducing every detail according to the photographic model that he used and whose production he considers mechanical, not creative. He represents these elements by giving them a pictorial existence. The play of the glazes, the coming to the surface of the delicate underdrawing, and the modulations of the paint handling suggest a vision that insists on both a natural aspect, through the authenticity of the illusionism, and its quality of artifice, as a clearly affirmed painted object.

This search requires the painter to retreat behind this tight, smooth handling that, in Verhaeren's eyes, produces meaning. This appears contradictory: whereas the tactile sensation produced by the handling of the paint invites the observer's eye to penetrate the image in order to become one with

it, the desire for objectivity inherent in the representation resolutely seeks to keep him at a distance. Absorption and contemplation are in mutual opposition.

The sensual technique that Khnopff derived from the early Flemish painters also underlines the sacred nature of the image vis-à-vis the material world. This detachment, which justifies recourse to photographic distancing, is expressed plastically and materially in the treatment of the painting as an object. Traditionally, the intensity of the glazes finds its ultimate resolution in the layer of varnish that heightens their luminous depths. Khnopff did not, however, varnish his portrait of Jeanne Kéfer. Examination of other works in the same vein shows this to be a systematic practice of his. Khnopff assigns the protective, glazing action specific to varnish to the windowpanes in his paintings. This rejection of varnish has various possible explanations. First of all, Khnopff wanted to preserve the delicate nature of the effects of texture, which varnish would tend to submerge under the same uniform aspect. This allows the artist to exploit the full range of possibilities, from brilliant to matte, to express in certain places the luminous expansiveness of the miniature and at others the sober flatness specific to fresco. At the same time, Khnopff distrusted varnish because it can discolor as it ages. Whistler's experience may well have served as a reference. At each of his exhibitions at Les XX, the American painter asked Octave Maus to make sure that his works were varnished so that their full splendor was apparent when hung.[111] Repeated too frequently, this operation sometimes produced disastrous results, as for example with the *Portrait of Pablo Sarasate*, exhibited in 1886. While praising the harmony of the palette and the composition, the journalist for *La Réforme* expressed regret that the work had been "dulled by several layers of coagulated varnish."[112] A sarcastic quatrain in *La Chronique* recorded the same effect:

> Not beautiful, our Pablo! It's saddening
> Varnished in this obscure range
> One would think he was back
> From a silver nitrate cure.

> *Pas beau, Pablo! C'est affligeant*
> *Verni dans cette gamme obscure,*
> *On croirait qu'il sort d'une cure*
> *Au nitrate d'argent.*[113]

Finally, varnish is a practice of a painter that does not correspond to the requirements of the draftsman. Félicien Rops, for example, when writing

his draftsman's "recipes" about 1877–79, devoted numerous passages to the varnishes he used to produce the "solid" effect of painting.[114]

Associated with the unity of a palette dominated by white—a reference as much to the immaculate paper as to Whistler's "arrangements"—the rejection of varnish is the mark of a "draftsman's painting," a phrase that characterizes Khnopff's oeuvre. Khnopff did not renounce certain characteristics of varnish but transferred them to the pane of glass that was part of the framing structure he developed between 1886 and 1888. Relinquishing varnish in favor of glass is of a piece with the development of a painter who drew his inspiration as much from his practice as a draftsman as from the work of the English Pre-Raphaelites.[115] Where varnish underlined the solidity of the painting, also rendering it more brilliant, the pane of glass is clearly distinguishable from the paint layer, providing a foil for its two dimensionality and thinness. The frame and the pane of glass contain the expansion of the painting and isolate it from the world, boldly declaring its status as a precious object.

A CIRCUMSCRIBED PERFECTION

At this level, the *Portrait of Jeanne Kéfer* confronts us with a problem. When placed on the art market in the early 1950s, the work had lost its original frame. At present, there is no way of telling what kind of frame Khnopff originally chose for this painting. Even so, certain features enable us to fill in the gaps. The role that Khnopff assigned to the frame is part of his conception of the image as an icon. In this way the frame concludes a process of development that began with the preparatory drawing. The frame signals the completion of a process of reflection on the image, whose development we have been able to follow, step by step, in the *Portrait of Jeanne Kéfer* [FIGURE 1]. Given its symbolic nature, the representation needs to find confirmation of its value in the frame: a complementary item that closes the image in on itself so as to render it inaccessible. From then on, the function the painter assigned to the frame reflected the evolution of his thought. Whereas *The Crisis* [FIGURE 7], painted in 1882, is still surrounded by a heavy frame, the works completed in 1886 present new solutions that reflect the requirements of a Symbolist icon. The *Portrait of Jeanne Kéfer* is pivotally positioned between these two stages.

Before adopting a type of frame that makes reference to an altarpiece,[116] Khnopff experimented with various decorative formulas that linked symbolically and plastically with the image. Under Whistler's influence, on several occasions he opted for a Japanizing frame in spun copper, to imitate

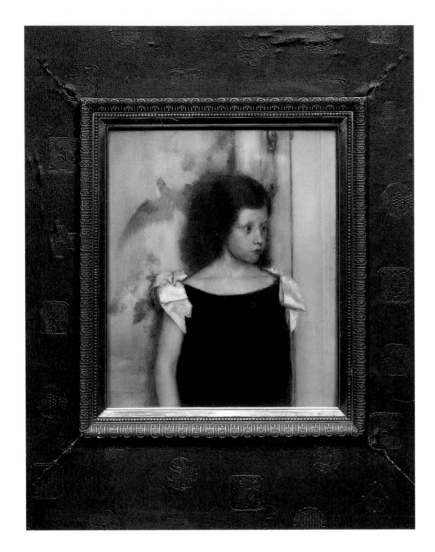

Figure 58
Fernand Khnopff,
*Portrait of Gabrielle
Braun*, 1886 [Figure 29
with frame].

Figure 59
Fernand Khnopff,
*Portrait of Gabrielle
Braun*, mock-Japanese
frame [detail of
Figure 58].

leather, with motifs inspired by Japanese curiosities taken from *Le Magasin Pittoresque*. A handful of examples have come down to us: the portraits of Gabrielle [FIGURES 29, 58] and Maurice Braun or, again, *Evening at Fosset*, painted in 1886, present the same wide frame decorated with constellations of flowers, mollusk shells, and fish,[117] evoking the circular motifs of Japanese *tsuba* saber guards [FIGURE 60] — which Whistler scattered across certain of his frames, including that of *The Little White Girl* [FIGURE 18].

The Whistlerian dimension of the *Portrait of Jeanne Kéfer*, its iconic density, intensified by the square canvas and the unity of its palette, makes this

painting a pivotal work: the laboratory of a Symbolist world that culminates in the frame. Had Khnopff already carried his thinking to this level of maturity? Everything suggests that he had. Not ready in time for the salon of Les XX in 1885, the *Portrait of Jeanne Kéfer* was presented a year later, at a time when Khnopff had already used "Japanese" frames for several of his portraits. If this kind of framing is essentially a response to fashion, at the same time it underscores the "arrangement" quality of these canvases by magnifying their preciosity. It is very likely that the "arrangement in emerald and gray" of the *Portrait of Jeanne Kéfer* was completed, like those of Gabrielle and Maurice Braun, with a Japanese-style frame. The restoration team and the Getty Museum's paintings curators speculate that the work was accompanied by a silvered frame with little appliquéd palm motifs like the one ornamenting the Symbolist effigy of his sister in 1887, or that of Madeleine Mabille in 1888 [FIGURE 61].[118]

Whatever its typology, the frame encloses the image in its timeless perfection. While the Japanese reference stresses its quality as an object, the iconic model confirms the spiritual unity of the image; the craftsmanlike preciosity of the former is contrasted with the Symbolist stripping of the latter. Historically, one seems to have followed the other, showing that by 1886 Khnopff had moved beyond the Whistlerian model.

Figure 60
Japanese Open-work
Tsuba Saber Guard,
with an Arrangement of
Shellfish and Bivalves
on Both Sides,
nineteenth century.
Gilded bronze, Diam:
7.5 cm (3 in.). Paris,
Musée des Arts
Décoratifs, inv. 6541.
Photo: Laurent Sully
Jaulmes.

A PORCELAIN ICON

From the close-up sketch to the final positioning with its photographic distancing, Khnopff works by successive degrees to isolate the image from its physical reality. The "photogenetic drawing" fixes the form in a spontaneous epiphany, while the brushwork defines it in a process of idealization. The painter evolves from one to the other. Suspended in time, the photographic instant favors the crystallization of a space that, by the play of the glazes, possesses its own luminosity. Here, too, the chemi-

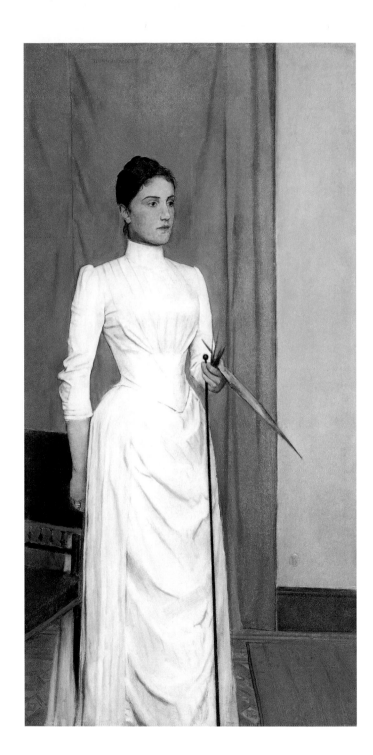

Figure 61
Fernand Khnopff,
*Portrait of Madeleine
Mabille*, 1888. Oil with
pencil highlights
on wood, 70 × 35 cm
(27½ × 13¾ in.).
Pittsburgh, Carnegie
Museum of Art,
93120. Heinz Family
Acquisition Fund.
Photo: Richard Stoner.

cal process that gives substance to the photographic image joins the technical process of painting. The ideas that feed one refer us to the other, evoking a unity of vision. It is as if the portrait is brought into being by the play of light on the canvas, in the same way that the photograph appears on light-sensitive paper.

The idealization process imposed by the painter on the model reduces the mimetic fidelity to a representation that evolves by formal *likeness* and symbolic *homonymy*.[119] Beyond the paint handling, the Symbolist portrait refers to the tradition of the icon, which continued to exist in Flanders throughout the late Gothic period, producing a practice of portraiture that extends to include Khnopff. The "photogenetic drawing" confirms the "natural" appearance of a face that, beyond the likeness, symbolically reveals the invisible. Photographic precision, just like the illusionism of the fifteenth-century masters, uses artifice to symbolically "deepen" the representation. The objectivity of the act of looking is not exhausted with the Realist dogma of the presentation but manifests this "living and intentional intimacy" of the visible and the invisible.

In painting as in photography, the act of looking plays a decisive role. Expressing the "spiritual nature of the contemplator's vision"[120] in the icon tradition, it also constitutes a door on a world beyond: giving access to a form of being that "makes holes" in the mask to which the photographed face is reduced. The obsession with the act of looking was a commonplace of Symbolism. For Khnopff, it is the eyes that resist the role society assigns to the model. Mademoiselle van der Hecht's Medusa-like gaze [FIGURES 19, 63] protects her from the invasion of the viewer. Gabrielle Philippson's eyes [FIGURE 71] take refuge, melancholically, in an inner withdrawal. Jeanne Kéfer's look takes on another significance: less intentional and provocative than that of Van der Hecht, less melancholy and absent than that of Philippson, Jeanne Kéfer's staring eyes constitute the symbolic "vanishing point" of a composition that affirms the impenetrability of an image inscribed in a single plane and set in a frame [FIGURES 62, 63]. While respecting the unity of the palette, the mixed Prussian blue and gray glaze suggests a depth in which existence is concentrated. While the composition suggests an almost immortal immobility, the model's eyes reveal palpitating life.

This tension constitutes one of the literary stimuli of the myth of the gaze in fin-de-siècle art. This gaze crystallizes the mystery of life. It is opposed to the mask, representing outward appearance, artifice, and lies. If the mask confirms the isolation of social life, contemplating the gaze awakens a desire for fusion that the Narcissus myth egotistically exalts.[121] Responding to the represented gaze is the gaze that effects this representation. The eye Khnopff paints is not passive. He endows it with a force that, for him, distinguishes it

from the passive vision of the photographer. It is this way of looking that makes the artist: "analysis, the omission of certain details, the disposing of the harmony"[122] are presented by Khnopff as various processes endowed with an artistic meaning not available to the photographer.

Like a camera obscura, the photograph "receives" the image that is printed on it. The creator's act of looking, on the contrary, is projected onto the world in order to impose his will on it by a mechanism that is less objective than metaphysical. From the drawing to the photograph, from the play of the glazes to the architecture of the composition, Khnopff has methodically pinned down his subject to abstract it from the world. In this way the image harks back to a process of petrification, rooted in the ancient myth of Medusa, which Khnopff illustrated on several occasions.[123] Through its frontality, the gaze constitutes the sole link between the child and the spectator at the same time that it crystallizes the presence of the model, made real by the painter. Instrumentalized by photography, reduced to a drawing, the body has been turned into a sign whose meaning is dependent on the act of looking.

This distance between the object depicted and the gaze, between the form that is arrested and the life that is totally summarized in the glint of the eye, gives Jeanne Kéfer the appearance of one of the china dolls then in fashion [FIGURE 64]. The play of the glazes immediately suggests this transpar-

Figure 64
Girl Doll, France, late
nineteenth century.
H: 35 cm (13¾ in.).
Body: porcelain head,
glass eyes, closed
mouth, blond hair, com-
position body and
limbs. Clothing: cotton
underclothes, woolen
dress with satin panels,
long-sleeved velvet
jacket, straw hat with
large bow. Antwerp,
Volkskundemuseum,
VM 62.73.1. Photo ©
Collectiebeleid, Bart
Huysmans.

Figure 65
Doll, late nineteenth
century. H: 73 cm
(28¾ in.). Porcelain
head with blue glass
eyes, open mouth with
teeth, painted eyebrows,
pierced ears, blond
woolen wig. Body:
leather upper arms and
legs, porcelain lower
arms. Antwerp,
Volkskundemuseum,
VM 92.63.24. Photo ©
Collectiebeleid, Bart
Huysmans.

ency of skin that marks the quality of bisque china produced in Germany and France in the late nineteenth century. Khnopff delicately modulates his palette to bring the skin to life without breaking the unity of the colors. As with dolls whose heads and hands are placed on wooden or leather bodies [FIGURE 65], the face protrudes from the costume without suggesting the existence of a real body.[124] Reduced to the effect of mannequin or automaton, this body is hidden, both in response to the dressing habits of the time and to further emphasize the isolation of the model.

Deprived of action, reduced to an object of contemplation, Jeanne Kéfer is treated like a doll that has been dressed before being submitted to the painter's gaze. The sober clothing, different from the garments that Khnopff was to use for certain of his adult female models, such as Yvonne Suys or Germaine Wiener, defines the model as a child. Jeanne Kéfer's coat is conspicuously muted, unlike the one worn by Yvonne Suys [see FIGURE 70]. Here the artist does not echo the imperatives of a commissioned portrait, which requires the model to be distinguished socially by the elegance of her garments and the nobility of her pose. On the contrary, Khnopff has concentrated on the environment of the representation, stripping the subject of most of her worldly artifice. Having become an instrument, the portrait reveals more than its simple anecdotal subject. Escaping partly from the social perspective,

it reflects on the human condition. The *Portrait of Jeanne Kéfer* [FIGURE 1] is not merely a representation of a child from the late-nineteenth-century Brussels bourgeoisie. It poses broader questions about identity and selfhood, as contained in a person's face and body.

The body itself does not directly intervene. Shaped by the garment, it appears cared for, "re-dressed," and disciplined by education. Khnopff plays on this state of concealment with a mastery that, three years later, was to impose itself as a closing-off in the emblematic portrait of his sister. If we apply a feminist analysis to the picture, the child's deportment participates fully in the structures of a patriarchal society, which denies the girl any desire for emancipation. The painter's brush fixes the girl in a conventional attitude in order to demonstrate—in a way perhaps similar to that of Whistler's *Cecily Alexander* [FIGURE 24]—a form of resistance to the male vision of infantile femininity. While adopting the position expected of her, the little girl offers resistance in the form of internal withdrawal. Did Khnopff really intend to portray this reserve? If the question must remain unanswered, it invites us first of all to examine more deeply the image of woman in the painter's work. Again we need to distinguish the commitment of the man from the image formulated by the painting. While appearing to subscribe to a characteristic fin-de-siècle misogyny, Khnopff's participation in the movement in favor of women's suffrage[125] calls on us to be prudent and to examine the subject from various viewpoints. In the present portrait, Khnopff opposes the resistance of the gaze to the submission of the body; the child submits physically but not psychologically.

Once again, the parallel with the doll refers us back to the photograph [FIGURE 66]. Khnopff uses his model like a marionette placed in the middle of a *tableau vivant*, submissive to the painter's will with the same force that Maurice Maeterlinck assigns to destiny, which moves the puppets in his *Death of Tintagiles* (*Mort de Tintagiles*). From the puppet tragedy to photography, the same process of alienation is at work. The doll restricts this reduction of being to its outer appearance, which Whistler evoked in his portrait of Cecily Alexander. Retreating behind her mask, the child appears closed in on herself. A creation, she exists only in metaphoric form: a photographic drawing and a doll made into a fetish, both of which are witnesses to the same privation of will. Reduced to graphic sign or passive automaton, she belongs to the painter just as the doll Coppélia, in the opera of that name, exists solely through her inventor.

The social logic connects with the social codes of the time. In this system, the act of looking plays a major role: the painter's look has frozen what the photographic eye had revealed by the symbolic action of light. Controlled

by the artist, the painting goes well beyond the action of the photograph, confirming this total mastery desired by Khnopff, the living picture (*tableau vivant*) joining hands with the still life (*nature morte*).

 This petrification, which appears to have overtaken the entire composition right down to the palette, dominated by marmoreal white, is nonetheless negated at one point: the child's gaze reveals the human being hiding behind the objective appearance of the doll and the mask.

Figure 66
Lewis Carroll, *Alice Liddell Wreathed*, 1860. Albumen print. Reproduced from Morton N. Cohen, *Reflections in a Looking Glass: A Centennial Celebration of Lewis Carroll, Photographer* (New York, 1998).

THE DISAPPEARING DETAIL

The focus on the look, already evident in the *Portrait of Mademoiselle van der Hecht*, finds here its radical formulation through the artifices that Khnopff has multiplied to reach the state of abstraction that characterizes the work: photogenetic drawing, sublimation of the handling, and creation of the body together produce that immobility of the visible that the gaze transcends to reveal the invisible. The symbolism undergoes a stripping-down that has perhaps justified a significant change in composition.

The examination of the *Portrait of Jeanne Kéfer* by Mark Leonard and his colleagues in the Getty Museum's Paintings Conservation studio uncovered a major surprise [FIGURE 67]. The X-radiographs reveal a detail—invisible to the naked eye despite the fineness of the glazes—that the painter had removed. In the original version of the work, Jeanne Kéfer held in her left hand a bouquet of white flowers, or possibly a single large flower.

We find this floral treatment in several of Khnopff's portraits. Was this particular version desired by the artist or requested by whoever commissioned the painting? It may be that Khnopff deemed the floral symbolism inappropriate for a little girl of five. Until this revelation, it had been thought that a flower first appeared in Khnopff's portraiture in 1890, in the *Portrait of Yvonne Suys* [see FIGURE 70]. However, the motif was not unknown to the painter when he staged little Jeanne Kéfer. In 1884, with *A Hydrangea*, he had

74

composed a narrative based on the symbolism of flowers. At the first level, the dialogue between the blue hydrangea and the rosebud can be read as a metaphor for the relationship that the painter maintained with the enigmatic woman absorbed by her reading.[128]

Flowers returned to fashion in the nineteenth century, their popularity enhanced by industrial and commercial attention.[129] The 1878 Paris Exposition Universelle had devoted an entire section to flower growing, both industrial and domestic. Exhibited there were the ne plus ultra of greenhouses, flowers and ornamental plants, vegetables, fruits and trees, seeds and plants, not to mention hothouse plants and artificial flowers.[128] In the immense greenhouses of the Champs de Mars, Khnopff, like the writers Huysmans and Villiers de L'Isle-Adam, discovered the mysterious charms of the flower that Baudelaire had intimately associated with evil. Among the attractions, we should also mention the greenhouse run by M. Linden, a gardener from Ghent of international renown whose rare species imported from Latin America aroused the enthusiasm of both the public and specialists.[129] The same Linden had founded in the magazine *L'Illustration Horticole* in 1854, which, until 1896, informed its readers of rare species, of the hidden meanings of different plants, and of their specific features. The review also provided a rich repertory of symbolic motifs that Khnopff was to draw on, in particular for his representation of vengeance in a pastel of 1895 entitled *Némésia* [FIGURE 68]. Here the woman no longer plays with the flower as an emblem—she has become its allegorical incarnation.

The whole of Europe was swept with an enthusiasm for things floral, and the culture of flowers was rapidly endowed with its own language, beginning with Émile Gallé's postulation that flowers reveal the structure of human thought.[130] The language of flowers was understood as a universal one, based on a long tradition. Picking up the heritage of past centuries, books offering the key to the symbolic meaning of flowers proliferated. In 1811 Bertrand Delachénaye published his *Floral Primer, or the*

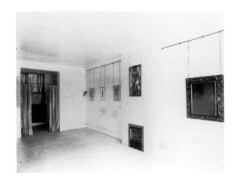

Figure 69

The White Drawing
Room in the House that
Khnopff Had Built
in Brussels in 1902.
On the chimney piece,
a reproduction of
Edward Burne-Jones's
Wheel of Fortune.
To its left, *At Fosset:
Under the Pine Trees*,
and to the right,
a series of drawings

among which is
recognizable, to the
right, *The Necklace of
Medals*. In the corner,
a vase of flowers hangs
at the height of the
pictures so that the
viewer can breathe
in the fragrance of the
flowers while con-
templating the images.

Language of Flowers (*Abécédaire de flore, ou langage des fleurs*); it was followed, in 1819, by *The Language of Flowers* (*Le langage des fleurs*) by Charlotte de Latour. Titles appeared one after another in an ambiguous mix of botany and symbolism with moralistic overtones. Much of this was based on mythological references, with flowers' meanings explained by reference to foundation myths. Botanical objectivity was twinned with archetypal meanings, permitting a gradual and imperceptible shift from scientific representation to symbolic evocation. This codified flower language opens the way to a hermetic discourse, carrying on the "hidden symbolism" of the early Flemish painters. In this way flowers are imbued with the ability to express ideas and feelings without disturbing a representation that at first sight is limited to outward forms.

This language does not operate unequivocally. Behind these coded messages, according to de Latour, there lies love: not just the language of the sexes, but that of pure feeling. In the author's words, "Flowers lend their charms to the language of amity, recognition, and filial and maternal tenderness."[131]

Symbolic and sensual, flowers cast a spell; consciousness and standards give way under the light narcosis of their perfumes. Khnopff portrays his image of the solitary artist as being internationally renowned, a member of many elite groups and a participant in powerful commercial circles, but nonetheless an aesthete secluded in his ivory tower, who paints while inhaling the perfumes of a few rare species.[132] The physical makeup of the image is eloquent in this respect. Its task is to create an "industry of rarity" that, marrying hermeticism of meaning with preciosity of sensation, attests to an exceptional situation. The house that Khnopff had built for himself in Brussels in 1902 is the final point of this quest. House — but who will really live there?—temple, setting, personal museum, and personal stage, this "dream castle" appears like a kind of all-encompassing creation. Flowers have their role here, blossoming hieratic and solitary in a minimalist garden before being transfigured into fragrance

[FIGURE 69]. Khnopff carefully organized the spaces, providing each room with perfume diffusers to "accompany" contemplation of the works hung on the walls—an early form of today's aromatherapy. Elsewhere the flower is associated with the mask of Hypnos to present, in allegorical mode, this "woman absent from every bouquet" dear to Mallarmé. Meaning is a matter less of code and more of sensation. The flowers are to be organized in emblematic tableaux, each species associated with a state of the soul, to be completed by the symbolism of the colors. This esoteric system of floral emblems testifies to a desire for hermeticism that, in Khnopff, shares in the same aristocratic feeling.[133]

With his knowledge of English and transplanted English painters such as Dante Gabriel Rossetti and John Singer Sargent, Khnopff introduced the flower motif in 1885 in the first version of the *Portrait of Jeanne Kéfer*. What significance should we attribute to it? Given our inability to determine what flower the child is holding, despite the quality of the X-radiograph, it is impossible to refer the reader to one or another floral dictionary. At best, we can place the motif in Khnopff's discourse. To do this, we must make comparisons with other portraits.

In 1890 Khnopff painted the *Portrait of Yvonne Suys* [FIGURE 70]. Once again this was a child from the artistic and intellectual circles of Brussels, her father none other than Léon Suys, one of the main city planners, responsible for the Stock Exchange (1868–73) and the Halles Centrales (covered market, 1872–74), among other buildings. Paradoxically, here Khnopff did not try to cast the child into an unapproachable distance as he had done with Jeanne Kéfer. This more-worldly portrait attests to a conventional proximity. The face retains its perfect readability, with the girl's hair and bangs delineating her individuality. The child is neither mysterious nor dreamy. Rather, she yields to a social exercise with an ease rendered explicit by the blood-colored iris she holds. The flower completes the young girl, saying more about her than she herself reveals to us.

In the language of flowers, the iris means "message."[134] Without prejudging the liberties taken with traditional iconography, Khnopff has sought rarity: the iris is not the blue beloved of Monet or Van Gogh, but a color obtained artificially by the horticulturalist.[135] Its symbolism originates in mythology. Before taking male gender, Iris was a woman. Daughter of Thaumas, himself a son of the earth, she was the messenger of Juno, who, in reward for her services, placed her in heaven, where she personified the rainbow.[136] Changing gender, the iris transformed its symbolism of eloquence into a male principle. Was it Khnopff's intention to attest to his practice of portrait painting through the emblematic value accorded the iris?

The rare coloring of the flower appears to link it more to the orchid, to which the iris is related in popular speech, where it is known as the "garden orchid."[137] Of Chinese origin, orchids spread rapidly in Europe.[138] In the late nineteenth century, Ghent became famous for its orchids, which were sold all across Europe. Even so, this flower did not directly enter the collections of floral symbolism referring to women.[139] The literati—from the decadents to Proust—would attribute to it a sexual meaning based on its shape and an Eastern tradition disseminated by the vogue for things Japanese. Khnopff, whose interest in oriental cultures was nourished by his reading of L'Illustration, Le Magasin Pittoresque, and La Gazette des Beaux-Arts, appears here to be inspired by Chinese symbolism—well known at the end of the century—which makes the orchid the emblem of woman par excellence. Blood red, the orchid symbolizes marriage and fecundity.[140] As a precious flower, it also expresses spiritual withdrawal into oneself and a desire that grows and affirms itself.[141]

The language of emblematic flowers clearly directs our reading of the *Portrait of Yvonne Suys* along the path of sexual interpretation. Unlike Jeanne Kéfer [FIGURE 1], this young girl has nothing of the submissive doll about her, radiating an assurance emphasized by her less childish clothing. The flower exalts this ambiguity so that the portrait of the child foreshadows the portrait of a woman.

In his *Interpretation of Dreams*, Sigmund Freud analyzes a dream of flowers in which every symbolic figure becomes a "word bridge" to the unconscious, the flower evoking deflowering, the blush of the rose, desire. Freud adds:

> It should be indicated...that flower symbolism is very widespread: flowers, as the reproductive organs of plants, tend naturally to represent the human organs: flowers offered by lovers have perhaps in particular this unconscious meaning.[142]

A simple ornament governed by the complementarity of hues and the allusion to the language of flowers, the iris Yvonne Suys holds constitutes this double metaphor, revealing the destiny of a child soon to become a woman. It defines a symbolic passage that, in the nineteenth century, had its own rules.[143] Yvonne Suys is not entering into what our contemporary era refers to as adolescence; in her day this was reserved for boys. For girls, puberty immediately changed their social status. The onset of menstruation signified an initiation into adulthood, turning the girl into a woman. This new status, nearly as important as that of mother, at once conferred on her elegance, a harmonious shape, and a reserve and modesty that are radically different from the turbulence and insubordination of boys. What Khnopff delivers in the *Portrait of Yvonne Suys* [FIGURE 70] involves this symbolic passage from child to woman.

Figure 70
Fernand Khnopff,
Portrait of Yvonne Suys, 1890. Oil on wood, 72.1 × 47.9 cm (28⅜ × 18⅞ in.). Private collection.

It is likely that the obvious link between the flower and sexuality explains its removal from the *Portrait of Jeanne Kéfer*. The white color of the flower would have underlined the purity of this child, who was just five. An emblem of virginity, the bloom constituted a visual truism. The recourse to the symbol was not justified; on the contrary, its redundancy in the argument could have weakened the effect.

The second argument in favor of removing the flower lies in the logic of the composition. Judging from the X-radiograph of the flower, it formed a natural focal point for the observer's eye. As a symbolic ornament, it introduced an action that rendered emblematic Jeanne's very pose in front of the closed door. The ambiguity that was inserted in order to interrogate the apparently self-evident representation lost its strength. The removal of the detail led Khnopff to rethink his staging. This restaging is no less revealing than the obliteration of the language of flowers, allowing the painter to emphasize a certain passivity that takes the body in the direction of object. The child's left arm does not make sense in its earlier position. However, the painter refuses to redraw it entirely. Instead he "fixes" this now-empty arm by placing the fingertips inside the coat. Although logical, bearing in mind the different stages of the painting, the effect is no less surprising, as it seems to consecrate the enervation of this body entirely closed in on itself. The doll motif becomes clearer: the girl's body is as if traversed by the energetic gaze that magnetizes the viewer. The gaze is now the sole spiritual focus of the composition. The flower led to the allegorical anecdote, diverting the spectator's attention from the true subject of the image, which is the gaze. Once eliminated, the meaning attached to the floral motif can be rooted more deeply in those gray-blue eyes that define the "beyond" of the representation.

Thus, the abolition of the signifying detail realizes Khnopff's intention: to achieve an essential representation that, under cover of a perfect mastering of appearances, makes the image submit to the power of the gaze. This aspiration defines in Khnopff's work — but also more widely right across the Symbolist movement—a modern concept of the image as laboratory. The icon is not only this immaterial space where the invisible manifests itself in idealized form; it constitutes, at the same time, a point of passage that uses the visible to arrive at an understanding of the invisible. Part of the allegorical theater of a certain symbolism is this method of deciphering and understanding that defines the Symbolist method, delivering what Mallarmé calls the "pure concept."

The Portrait in Perspective

D ig deep into the verse," Mallarmé invites his readers. Following this advice, Khnopff "dug deep" into reality, drawing an image from it that suggests something far from obvious. Tracing the act of looking back to its source, Khnopff arrives at the central vacuum to which the myth of Medusa refers. Khnopff's Symbolist image constitutes a trap. The message inscribed at the center of the *Portrait of Jeanne Kéfer* refers to the iconography—still explicit—of *The Crisis* [FIGURE 7].

This aspiration, charged with negativity, echoes like an absolute renunciation of any representation. It explains the tone of melancholy that characterizes the figures in Khnopff's work, as if theirs is the task of documenting the impossible position in which the painter finds himself, that of still believing in what he is representing. Verhaeren was to summarize this state of consciousness by evoking "the realities too vividly perceived" by the painter. Reverie abolishes all distance, whereas representation requires distancing. From here on, the image operates in relation to these two instants: that of voluptuous absorption and that of objectification, which forbids any access even to that which takes shape with the act of looking. The whole work tends toward representing Jeanne Kéfer. She, however, cannot exist independently of the painter, who uses her to project himself. The contour that "names" every painted object flawlessly evokes both the object represented and the person painting it.

This induces, in the very heart of the practice of portrait painting, an ambiguity that Khnopff exploited to its fullest. Symbolist by conception, his portraits originate within the narrow confines of Brussels high society. In portraying the children and then the women of this class, such as Madeleine Mabille or Isabelle Errera, Madame de Bauer or Madame Franz Philippson, Khnopff reveals a mastery that, under the glaze of appearances, was to flatter the taste of a then-triumphant bourgeoisie. His work lies at the center of a social system

that Khnopff exploited commercially, developing a name for himself that would soon be known beyond the borders of Belgium. Unlike Jeanne Kéfer, who, through her father, belonged to the same artistic milieu as Khnopff, the models whom the painter portrays from 1887/88 onward belong to the high society within which he now worked.

Critics were quick to rail against this social success, which Khnopff appears to have acquired in 1886 with the *Portrait of Jeanne Kéfer*. From then on, Khnopff was honored with major commissions in Belgium, in France, and across Europe, while his name was held in esteem by the main Secessionist groups, so much so that in 1900, the Austrian emperor Francis Joseph I (1830–1916) asked Khnopff to paint a posthumous portrait of Empress Elisabeth.

This practice of painting portraits on commission did not, however, interfere with Khnopff's Symbolist research. Proof of this is the fact that Khnopff continued to show his portraits at exhibitions where he also presented "logo-griphic" works such as *Memories* [FIGURE 39] and *Silence*. This mixture is justified first of all by the independence of portraits such as those of Jeanne Kéfer and Madeleine Mabille from their models. Khnopff transcended the exercise of portrait painting to make it a work complete in itself [FIGURE 71]. At the same time, it emphasized the artist's status on the Belgian and European cultural scenes.

KHNOPFF VERSUS VAN RYSSELBERGHE

In 1886, on the subject of the *Portrait of Jeanne Kéfer*, Lucien Solvay—who, in 1883, had been asked to be secretary of Les XX—criticized Khnopff's dizzingly successful production:

> One day he exhibited a child's portrait that delighted every mother. Since then he spends all his time painting children's portraits, and all these children are pretty (they have to be; if not, he would not agree to paint them) and all these portraits are delightful. The success of these two or three newborn infants at the exhibition of Les XX is deplorably unanimous. . . . I would be furious to be admired by everybody and to see so many mothers come and beg me to do their babies.[144]

The works Khnopff produced around 1885—of which the *Portrait of Jeanne Kéfer* is among the foremost—were to considerably influence the artists who, in his wake, were interested in the portraits presented by Whistler. Théo van Ryssel-

Figure 71
Fernand Khnopff,
*Portrait of Madame
Franz Philippson*,
1899. Oil on canvas,
75 × 67 cm
(29 ½ × 26 ⅜ in.).
Private collection.

Figure 72
Théo van Rysselberghe
(Belgian, 1862–1926),
*Portrait of Marguerite
van Mons*, 1886. Oil
on canvas, 90 × 70 cm
(35⅜ × 27½ in.).
Ghent, Museum
voor Schone Kunsten,
1979-C.

berghe's portraits of the sisters Marguerite [FIGURE 72] and Camille van Mons, painted in June 1886, pay their debt to Whistler via an essentially Khnopffian interpretation. Here Van Rysselberghe has moved away from the essentially Realist character of his production—still tangible in his *Portrait of the Schlobach Sisters*, painted in 1884 and exhibited at the second Salon of Les XX, as well as in the *Portrait of Octave Maus*, painted in 1885—toward a more decorative formula.

As Jane Block has shown,[145] the portrait became a major element of Van Rysselberghe's creative work. No fewer than eight of the eleven paintings he showed at the 1886 salon of Les XX were in this genre. Like Khnopff, Van Rysselberghe was not yet, however, recognized as a society portraitist. Like Khnopff, he chose his models from his immediate circle.[146] His participation in Les XX in 1886 probably also indicates a desire to build up a customer base

in the popular genre of portraiture. The fashion effect dominates here without ever falling into radicalism.

The *Portrait of Marguerite van Mons* [FIGURE 72] reflects Whistler's influence, but it also reveals the effect on Van Rysselberghe of Khnopff's interpretation of Whistler in the *Portrait of Jeanne Kéfer*. The setting is comparable in every particular: a child, captured in a bourgeois interior, is presented with a frontality that defines itself spatially in the framing of the door. Van Rysselberghe, however, refuses the distancing imposed by Khnopff in order to retain the portrait's narrative pretext. Preferring a close-up vision more in conformity with the portrait tradition, he gives the child a gesture that renders explicit— and in so doing weakens — her relationship with the door. A gesture of the right hand allows the girl to open or close the door. The movement breaks the strict inscription within the plane, and the flat, rigorous layering of space gives way to an ambiguous sense of depth. This strangely distorted arm seems to have been deprived of volume to fit into the logic of the plane. The fold in the bend of the arm, as well as the slight shadow, testify to this inconsistency, revelatory of the conflict opposing the realism of the action to the logic of the space treated in flat planes.

In reducing analogy to narrative, Van Rysselberghe renders explicit what with Khnopff remained suggestion. The former's concern for realism gains the upper hand. He multiplies the details of the framing elements—with their ornamental foliage and bourgeois ironmongery— at the risk of diluting his subject in a profusion of effects. Comparison between the two artists highlights both Khnopff's originality and his desire to eliminate from reality everything that does not reflect his ideal. With Van Rysselberghe, the elements respect the representation to the detriment of the meaning. Comparison with the *Portrait of Jeanne Kéfer* gives significance to certain omissions of Khnopff's. For example, by eliminating the second keyhole, Khnopff has concentrated the observer's eye on the remaining one, whereas Van Rysselberghe has simply rendered faithfully a conventional decorative item.[147]

TOWARD THE SYMBOLIST PORTRAIT

Acknowledged as a specialist painter of children in the same way that others are painters of "civil guard officers and company chairmen,"[148] Khnopff provides a symbolic portrait typology freed from the social exercise at work in many of his portraits. The *Portrait of Jeanne Kéfer* becomes in this way a milestone in the evolution of Khnopff's conception of Symbolism.

In the portrait of a child, a personality shows through an appearance, first of all in the crystalline purity of the gaze, which resists the will of the artist, then, as the child grows toward adulthood, in an attitude that affirms the femininity that the floral emblem reveals and emphasizes. The relationship with the painter is transformed. No longer resisting, the woman becomes a temptress. The gaze does not reject; rather, it attracts with a sinuous movement that is prolonged in the arabesque of the body. The theme of temptation, which the artist had already explored in 1883 in his *Queen of Sheba*, becomes a constituent part of the relationship to the other. Burne-Jones's *Vivien* serves as a model here. Moving from painting to sculpture, Khnopff reverts to this theme of temptation through the gaze. He himself describes this in poetic form:

> With a long gaze, he follows the attracting spiral
> And the undulation of the beautiful, balanced body.
> She sees the Enchanter—with his condensed knowledge
> Yield to her power and lose himself in a dying groan.

> *D'un long regard, il suit l'attirante spirale*
> *Et l'ondulation du beau corps balancé.*
> *Elle voit l'Enchanteur—au savoir condensé*
> *Céder à sa puissance et se perdre en un râle.*[149]

From the eyes to the body, the gaze concentrates this rout of objective consciousness already expressed in the *Portrait of Jeanne Kéfer*. With the child in front of him, Khnopff gives us a reflection that, by its questioning of the act of representation, anticipates the definitions of Symbolism formulated by such writers as Moréas, Kahn, and Verhaeren in 1886. In this respect, the latter's essay on Khnopff constitutes a full-fledged manifesto.[150] The "objectivization of the subjective" that Kahn preaches includes recourse to photogenetic drawing, the moving away from "academic" finish, and the glorification of the image into an aesthetic object, all practiced by Khnopff in his *Portrait of Jeanne Kéfer*.

A FACE FOR AN IDEAL

The idealization of the face responds to the desire to have the model adhere to a skillfully constructed typology. It was this need that in 1885 produced the "Caron affair." The face of this singer at the Théâtre royal de la Monnaie, in a portrait by Khnopff, by degrees moves from that of Rose Caron to the enchanting features of Leonora d'Este in Joséphin Péladan's *The Supreme Vice*

[FIGURES 73, 74]. The scandalized actress called for the destruction of the painting[151] out of respect for her own image. Khnopff acquiesced, but the scandal aroused by the affair continued unabated.[152]

 The portrait of Rose Caron—which almost certainly remained uncompleted—was produced simultaneously with that of Jeanne Kéfer [FIGURE 1], and quite probably in relatively similar conditions. In the articles that he published to justify himself, Khnopff attempted to separate the exercise of the portrait from what he undertook in *The Supreme Vice*. For him, the work as exhibited did not resemble a painted portrait; instead, it was the fruit of an exercise of filtering undertaken by memory and by the artist's desire. Khnopff concludes, "If I had wanted to 'take' Mrs. Caron's head, it would have been easier, and certainly faster, to grab a photograph."[153] Khnopff's reply did noth-

ing to placate his detractors and brought into the fray his defenders, led by Péladan himself—who said that he was hurt by the loss of a masterpiece born of his own work[154]—and including Maus[155] and Picard.[156]

Khnopff's open letter is not without interest in that it reveals the mechanisms of the portrait. Here we find a description of the process that isolates the face from the body. While acknowledging a guilty likeness, Khnopff reduces this to a play of analogies and correspondences based on memory. That the model haunting him as he painted one of his recent portraits had assumed its features while he was reading Péladan's novel was an argument that Picard picked up during his pleadings in court. Donning a sociologist's hat, he questioned the mechanism leading to the incident. Khnopff had just finished reading a strange and upsetting book, "the most moving scenes of which he translates intellectually into pictorial images."[157] This act of translation proves vital: it transposed the model's face into a different system of representation that responded to its own mechanisms. In this play of poetic analogy, the figure of the woman—which Picard describes as "heroic and fragile, beautiful and terrible, caressing and funereal, and more than anything, enigmatic"—is seeking its "linear figuration." The artist is obsessed by this woman and, parallel with this, analyzes with his brush the "tragic, gentle" face of a female sphinx named Caron. The model takes on the features of the antique Gorgon, petrifying the painter's imagination: "She poses in front of him, and during the silent, studious sittings, her admirable, pale, accentuated, and immobile head detaches itself violently from her dark toilet."[158] This symbolic "beheading" allows the author to isolate the head from its everyday environment and identify it with the mythical figure of Leonora d'Este, while Picard seeks to demonstrate that this deflection derives from a pictorial reading present in Péladan's novel.[159]

The painter was obsessed with the heroine at two distinct levels: that of a legend that finds its face in Rose Caron and the encounter with works of art known to Khnopff and that he feels the need to equal in a new face. From the gaze to the ideal, from the symbol to reality, from the stage set to real life, and from the city to the artist's studio, Khnopff follows the linked series of ideas that mixes interior exaltation with the contemplation of the woman, the narrative with the icon, the idol with the diva. Picard insists on the work that seamlessly connects the development of Khnopff's wide oeuvre with the progression of the portrait. The lawyer plays on singular contrasts, passing from the silence reigning during the modeling sessions to the development of the narrative to which the woman is less and less foreign. Under his pen, Rose Caron imperceptibly becomes Leonora d'Este, right down to her personal features: rare beauty, energetic personality, impassive dignity. In turn Salammbô,

Salomé, Judith, and Vivien, the singer is unable to resist the role that Picard offers her in accord with Khnopff's multiple images. The faces fuse into one another, while the woman of flesh mutates into a "severe statue." Beyond the scandal, the Khnopff-Caron "couple" entered history in the company of Praxiteles and the Athenian beauties who served him as models: Raphael and Fornarina, Antonio Canova and Pauline Borghese.

Beginning with Khnopff's clumsy justifications, Picard's account details the unconscious mechanisms that animated the painter's imagination as he moved from the reality of the model to the illusory myth projected onto canvas or paper. The problem, as posed, makes particular reference to the esoteric machinery that the critic qualifies as enigmas, riddles, or "logogriphs." These take their inspiration in the literary world and their formulation in the fantasy worlds of Gustave Moreau or the Pre-Raphaelites. The "Caron affair" refers us back to Jeanne Kéfer, who constitutes the starting point of a process that tends toward the literary ideal as pure invention. Khnopff defines in this way two forms of likeness: the first is based on the mimetic fidelity inherent in a form reduced to its outer appearance; the second defines the relationship between the "pure concept" and the form that it takes. Under this heading the *Portrait of Rose Caron* and *After Joséphin Péladan: The Supreme Vice* constitute two portraits of the same reality, the first describing outwardly what the second reveals inwardly. In resolving to destroy his work, Khnopff had to be conscious of this connection, whose justification resides in the artificial nature of the representation.

THE SYMBOLIST PORTRAIT

As we move beyond the discussion of the image, the function of portrait painting in Khnopff's work becomes clearer. It is an experimental place, where the model's features nourish a literature-based imaginary world that the painter excavates, amplifies, and corrects in order to transform a narrative into vision. It would, however, be an oversimplification to describe a path leading from the actual fact to mythical invention.

According to his own explanation, the fashionable painter was seeking less an individuality affirming itself before him than the slow elaboration of a feminine type that, imperceptibly, steals from one woman and then another the fragments of an absolute perfection, with which the artist creates an ideal femininity. Before he concentrated on the adult woman, the quest started with the child. This search is not immediately evident, hidden behind

the pretext of the portrait, dependent on photographs, and with references to the models handed down by tradition. From the preparatory drawing to the completed work, the portrait evolves toward a necessarily artificial perfection.

The "Caron affair" was a dramatic episode for the painter, who could not bear to see his secrets exposed in the press for all to read. It profoundly changed his relationship to his models. Inspiration would no longer be seized wherever he found it but would be limited to the features of accomplices like his sister or a few select models such as the sisters Elsie, Lily, and Nancy Maquet, whose features he would draw, modify, and purify until he reached the ideal type that Ensor was to deride:

> Mr. Khnopff's Venus-like effigies are a dignified celebration of the Eternal Feminine, a milieu of Medusas, reptiles, panthers, prawns and eels, where carp and female rabbits intertwine any old how. . . . Platonic dissector of the occiputs [back part of the head] of worm-eaten mannequins, tenacious grisaille-painter overstuffed with splenetic banalities. A latecomer Mona Lisa painter, extra-superannuated, Mr. Khnopff remains first and foremost the uncontested cantor of enigmatic female sphinxes with unfathomable undergarments smelling of the mysterious.[160]

THE PORTRAIT OF THE ALTER EGO

Abstract and stripped bare, the *Portrait of Jeanne Kéfer* inaugurated a formula that Khnopff continued to plumb. The *Portrait of Marie Monnom* [see FIGURE 28], produced in 1887, was his first portrait of an adult woman. The staging remains conventional. Marie was the daughter of the publisher who, that year, had brought out the articles that Verhaeren had devoted to Khnopff one year before in a separate volume. The painting offers the motionless recital of these sittings devoted to an "arrangement" in gray and blue. To this minimal narration, Khnopff would soon oppose an iconic construction taken directly from the *Portrait of Jeanne Kéfer*.

The face of Khnopff's sister Marguerite rapidly took hold of her brother's imagination. Almost certainly it is already present in the anonymous features of the sketchbooks from 1875 to 1880. In the years after the "Caron affair," Marguerite's features circumscribe the feminine type that the painter developed, without any necessity for psychoanalytic explanations.[161] She lends herself to the work of simulation that Khnopff elaborated, starting with photography. In 1887 the Antwerp viewing public discovered her hieratic portrait

Figure 75
Fernand Khnopff, *Portrait of Marguerite Khnopff*, 1887. Oil on canvas, 96 × 74.5 cm (37¾ × 29⅜ in.). Brussels, King Baudouin Foundation, given in safekeeping to the Musées royaux de Beaux-Arts de Belgique.

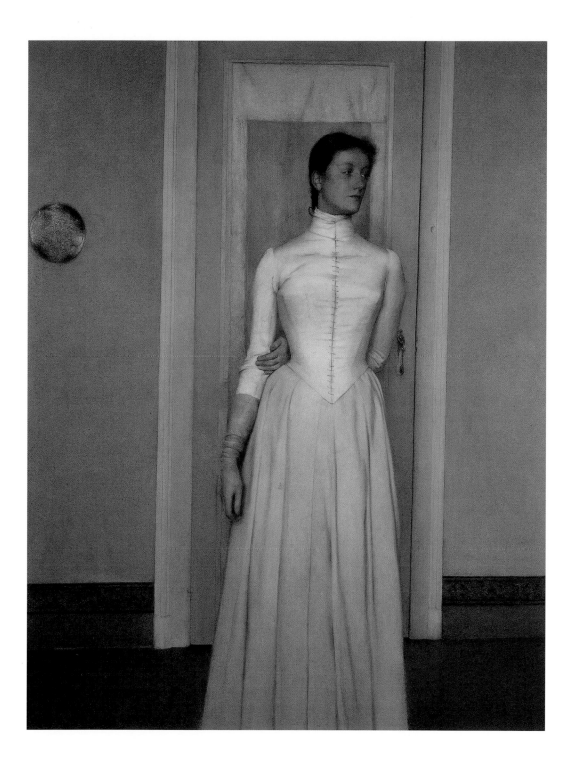

at the exhibition *L'Art Indépendant*, a portrait that would henceforward constitute the archetype of Khnopffian portrait painting.[162]

 This painting follows directly from the *Portrait of Jeanne Kéfer*. The composition follows the same mechanisms, while radicalizing them. Marguerite's silhouette stands out against an abstract background [FIGURE 75]. In the studio, the painter has placed the woman within the outlines of a door that appears to contain her entirely. What was only suggested in the case of Jeanne Kéfer becomes explicit: the body is the prisoner of this frame, which compresses its silhouette. A solitary figure, Marguerite becomes the symbol of confinement. This includes the way she is dressed. Marguerite appears imprisoned by her dress. Begloved, begirdled, bedraped, all we see is her face, announcing the *Mask of a Young English Girl*, which Khnopff produced in *gessoduro* about 1893. The clothing marries totally the body that it hides. Opaque like a suit of armor, it repulses the gaze and defies any desire. Khnopff plays skillfully with details. As the *Portrait of Madeleine Mabille* shows, Marguerite's dress ought to lace up the back. Placed in the front, this closure functions like an obsessive photographic *punctum*. Closed tight like a finely sutured wound—at least this is the reading that Jean de Palacio proposes based on a rich set of arguments taken from decadent literature[163]—the laces confuse clothing and skin in a single impenetrable surface. This skin has taken on a marblelike coloration that the *Portrait of Jeanne Kéfer* reserved for the decor. Ought we then to follow this specialist of fin-de-siècle literature and associate this suture, in a Freudian vein, with an inviolable virginity? The scar unveiled in this way—looking closely at the canvas, one has to acknowledge, apart from its vertical positioning at the very center of the composition, the fetish-like, almost painful, care with which it was painted—emphasizes in particular the reclusion of this solitary figure. Intellectually this interpretation is all the more seductive for making the *Portrait of Marguerite* a response to Whistler's *Little White Girl* [FIGURE 18], which ostensibly served as its model.[164]

 To underline the unity of the image with the surface, Khnopff does not represent the woman at full length. He no longer feels the need to push her out of the foreground by the artifice of placing the floor in perspective. This distancing, still explicit in *Jeanne Kéfer*, is entirely included in the image itself, which from now on constitutes a universe that is inaccessible to the spectator: an unchanging world dedicated to an archetypal truth, the sacred nature of which is further emphasized by the frame inspired by altarpieces.

 Khnopff has returned also to the question of the gaze. Whereas Jeanne Kéfer's eyes constituted the ultimate point of resistance of an interior world threatened by representation, Marguerite's gaze turns away from strict frontal-

ity, refusing any contact with the viewer. Her eyes slip past her left shoulder, losing themselves beyond the frame. The apparition withdraws from our gaze. Just like the closed door, the woman remains a recluse in a dream that forbids any action and permits us only to wait.

In a stratified and vitrified space like the one that Jeanne Kéfer inhabits, Marguerite's body has taken its place as one surface among others, fixed and motionless as a hieroglyph. The left arm, behind her, circumscribes the slice of space that the female figure occupies: a narrow layer in the foreground of the image. Despite a posture that ought to make her chest stand out, Marguerite lacks any real depth. Her left arm accompanies, as its vector, the vertical movement of the body. Only the head breaks from this strict axiality, further emphasized by the obsessive movement of the laces of the bodice. She escapes from frontality into a three-quarter profile. The movement appears uncomfortable. Is it hindered by the cutting rigidity of the collar or by some violent interior movement? Her feigned disdain of the viewer testifies to a theatricality felt since Diderot, aimed at neutralizing the spectator's presence and imposing the fiction that there is never, and never can be, anyone looking at the image.[165] The apparition looks only at herself. Her look avoids us, directed, not at the outside world, but at the painter himself. Khnopff was to stage this isolation allegorically in a series of works illustrating an esoteric cult offered to the image via the act of representation itself: *A Gesture of Offering*, the different versions of *Incense* [FIGURE 53], *Secret*, and *Silence* are all visual testimonies of a ritual that takes the icon for its subject and object. These drawings, recognized today as the very expression of Symbolism in painting, are in fact only the narrative—literary—development of a static presence that the portrait transforms into an icon. A new conception of representation derives from this encounter.

BEYOND THE PORTRAIT

This natural progression from the interrogation of reality to the affirmation of the idea is based on a production of the image following the codes attached to its theatrical staging. The impact of Alfred Stevens's *Lady in Pink* is vital in the relationship to the setting, marking the origin of what Verhaeren calls "the great evocative decors" in that women reveal themselves not only in their Parisian modernity but also in their melancholic withdrawal into a secret intimacy. A mimetic precision is attached to the rendering of the materials, to the tactile sensibility of a form of looking, that does not so much observe the objects as attempt to penetrate their soul. The surface awakens an interior

dream buried beneath the appearance. Woman of the world, with a strongly confirmed social sense, the figure also reveals itself as the bearer of a secret life, an acute sensibility revealed by the animist whiteness and its symbolic variations. The tender coloring of Stevens's painting would remain in Khnopff's mind, and, with tiny analogies, would link the profusion of muslin to the dreamed-of scent of a camellia.[166]

The mimetic precision is evidence of a mastery of artifice that Roger de Piles had already pointed out. Khnopff's painting attests to his "harmonious economy that arrests the observer, entertains him, and invites him to enjoy the particular beauty found in the painting."[167] The glazing technique not only produces a perfect, academic finish but also guarantees the economy of the surface on which the eye fixes in a close-up reading. The miniaturist's work betrays an obsession with the act of looking, leading to the frenzy of touch.

Khnopff has extracted Marguerite's inaccessible image from reality in an initial drawing that now nourishes the Symbolist project: to disengage from the natural spectacle a "pure concept" that the image will render sacred. The process of producing the painting, as introduced in the *Portrait of Jeanne Kéfer*, now turns into a ritual, substituting the truth of the world of the imagination for the illusion of reality.

Painted in 1895, *Arum Lily* [FIGURE 76] can be seen as the emblematic staging of Marguerite's portrait. It is the same feminine type offering herself in an identical pose. The symbolism is expressed in the mirroring of the representation, which parallels the idealized figure of the woman and the flower whose name sets off a series of suggestions: in its English formulation, the arum, an old world plant with arrow-shaped leaves and a showy spathe, evokes the lily and refers to the first name of one of the three Maquet sisters, Lily, whose features we find here. Khnopff plays on floral symbolism to suggest an analogy between the woman and the flower. Both deploy their parallel mysteries in suggesting a recovered harmony. Their juxtaposed shapes set in place a chain of symbolic meanings without its being possible to reduce the one to the level of ornament of the other. Other elements appear with no precise interpretation: a column, a garland, and even the strange foreground, where a cut-off face in demi-grisaille (a petrified head or animated sculpture) is visible in profile, while a strange utensil (a weapon or sacrificial object) cuts across the dress. The hermetic composition attests to a degree of reality that maintains with the material world a relationship of appearance only. The logograph lends itself to exegesis in an enigmatic gesture of offering. Through the image, Khnopff delivers a meaning; the mechanisms for representing this meaning seem to originate from a different world with a different kind of

Figure 76
Fernand Khnopff,
Arum Lily, 1895.
Photograph by Arsène
Alexandre, highlighted,
29.5 × 19.5 cm
(11⅝ × 7⅝ in.).
Private collection.

logic. The spectator stands in front of the composition like an archaeologist in front of a stele covered with indecipherable inscriptions. It is now not just the model's look that resists, but the entire composition that incarnates a truth that has been lost forever.

In 1898, at the first exhibition of the Vienna Secession that would promote Khnopff's triumph, the critics pointed to this sensation of impenetrability of an image, whose smooth handling and photographic illusionism nonetheless seemed to promise a strict legibility. "Nobody," Ludwig Hevesi wrote, "would have believed that the Brussels super-mystic would have carried off such a success in Vienna, even confirming it with serial purchases. Khnopff the obscure in the Vienna of light."[168] The ambiguity of the poetic image attains its paroxysm: Khnopff no longer makes any distinction between the material world founded on a void and the world of his literary imagination erected into a realistic fiction. One is only the froth of the other. The latter reveals the archetypal mechanisms rising to the surface of the former. In the hermetic image that Khnopff delivered, sheltered by a frame that has become an impassable threshold, "everything appears linked by a secret relationship without this necessarily being so."[169] The smallest detail contains both meaning and an unsolvable riddle. There can be no doubt that the *Portrait of Jeanne Kéfer* provides a vital key to our reading of this game. As the laboratory of the Khnopffian image, the painting attests to aspirations and tensions that herald the advent of the Symbolist icon.

1 On Khnopff, see J. Howe, *The Symbolist Art of Fernand Khnopff* (Ann Arbor, Mich., 1982); R. L. Delevoy, C. de Croës, and G. Ollinger-Zinque, *Fernand Khnopff*, 2nd ed. (Brussels, 1987); and M. Draguet, *Khnopff ou l'ambigu poétique* (Paris, 1995).

2 H. Bahr, *Secession* (1900), French translation in *Fernand Khnopff et ses rapports avec la Sécession viennoise*, exh. cat. (Brussels, Musées royaux des Beaux-Arts de Belgique, 1987), p. 83.

3 É. Verhaeren, "Silhouettes d'artistes: Fernand Khnopff," in *L'Art Moderne* 6, no. 36 (September 5, 1886), p. 282.

4 The essay, which first appeared as a series of articles in *L'Art Moderne* in 1886, was published one year later. See É. Verhaeren, *Quelques notes sur l'œuvre de Fernand Khnopff, 1881–1887* (Brussels, 1887).

5 C. Berg, "Le lorgnon de Schopenhauer: Les symbolistes belges et les impostures du reel," in *Cahiers de l'Association Internationale des Études françaises*, no. 34 (May 1982), p. 119.

6 On the history of the Cercle des Vingt, see J. Block, *Les XX and Belgian Avant-Gardism: 1864–1894* (Ann Arbor, Mich., 1984); *Les Vingt en de avant-garde in België: Prenten, tekeningen en boeken ca. 1890*, exh. cat. (Ghent, Museum voor Schone Kunsten, 1992); and also *Les XX et La Libre Esthétique: Cent ans après*, exh. cat. (Brussels, Musées royaux des Beaux-Arts de Belgique, 1993–94).

7 The group also included Paul Dubois, Willy Schlobach, Jef Lambeaux, Willy Finch, Périclès Pantazis, and Guillaume Vogels, together with older artists from a more academic tradition such as Jean Delvin, Frantz Charlet, Frans Simon, Théo Verstraete, Charles Goethals, and Gustave Vanaise. The latter would gradually cede their place to such varied personalities as Anna Boch, Félicien Rops, Henry van de Velde, and Paul Signac.

8 E. Picard, "L'Exposition des XX: L'Art jeune," in *L'Art Moderne* 4, no. 7 (February 17, 1884), pp. 49–51.

9 On Brassin's Wagnerian activity, see M. Couvreur, ed., *La Monnaie wagnérienne* (Brussels, 1999).

10 On Anna Boch, see C. Dulière and T. Thomas, *Anna Boch* (Brussels and Morlanwelz, 2000).

11 See here in particular *Souvenirs d'un wagnérien: Le Théâtre de Bayreuth*, which Maus published in 1888. See also A. van der Linden, *Octave Maus et la vie musicale belge* (Brussels, 1950).

12 At this concert Kéfer (piano), Lerminiaux (violin), Agniez (viola), Jacob (cello), and members of L'Essor played four movements of the Quartet in A Major, opus 26, the Variations and Fugue on a Theme by Handel, opus 24, and four movements of the Quartet in A Minor, opus 25.

13 The concert program lists three parts: Naumann's Serenade, opus 10, Schubert's Three Fairy Tales, opus 32, and the Quintet, opus 114, known as The Trout, again by Schubert. In Maus's account of the event ([O. Maus], "Momento musical," *L'Art Moderne* 4, no. 7 [February 17, 1884], p. 53), the critic notes that Schubert's opus 32 was replaced by a work by Mendelssohn. The concert program, preserved in the Contemporary Art Archives of the Musées royaux des Beaux-Arts de Belgique, lists the members of the Union Instrumentale: Kéfer, Achille Lerminiaux as first violinist, Lucrin Vandergotten as second violinist, Alphonse Agniez on the viola, Joseph Jacob on the cello, Émile Danneels on the double bass, Théophile Anthoni on the flute, Émile Plétinckx on the oboe, Gustave Poncelet on the clarinet, Alphonse Gentsch on the French horn, and Raoul Devos on the bassoon.

14 E. Evenepoel, *Le wagnérisme hors d'Allemagne (Bruxelles et la Belgique)* (Paris, Brussels, and Leipzig, 1891), p. 114.

15 M.-O. Maus, *Trente années de lutte pour l'art, 1884–1914* (Namur, 1926; Brussels, 1980), p. 28.

16 Gustave Kéfer played the piano, accompanied by his brother Louis on the violin and Édouard Jacobs on the viola. The baritone Henri Heuschling interpreted for the occasion the songs and melodies of Gustave Kéfer (*Chansons et mélodies* [Brussels, 1890]).

17 Among the identified works of Kéfer, we would also mention his Andante for Cello with Piano Accompaniment, opus 4 (Brussels and Leipzig, undated).

18 Maus (note 15), p. 123.

19 Archives et Musée de la Littérature, Brussels, ML 2251.

20 Verhaeren (note 3), p. 322.

21 R. Leppert, *The Sight of Sound: Music, Representation and the History of Body* (Berkeley and Los Angeles, 1993), pp. 71–74.

22 Verhaeren (note 3), p. 322.

23 É. Verhaeren, "Les symbolistes," *L'Art Moderne* 6, no. 41 (October 10, 1886), p. 324.

24 Verhaeren (note 23). Verhaeren makes his own here an equally explicit passage from Gustave Kahn's text: "we wish to replace the combat of individualities with the combat of sensations and ideas. Our field of action is not the hundred-times-repeated decor of crossroads and streets, but rather all or parts of the brain. The essential aim of our art is to objectivize the subjective (exteriorization of the idea) instead of subjectivizing the objective (nature seen through a temperament)."

25 *Les XX*, exh. cat. (Brussels, Palais des Beaux-Arts, 1885), no. 3. In addition, the portrait of Gustave Kéfer was to have been shown as no. 1.

26 *Les XX* (note 25), no. 4.

27 *L'Art Indépendant*, exh. cat. (Antwerp, Palais de l'Industrie, des Arts et du Commerce, 1887), no. 85.

28 *Annual Exhibition of the Royal Society of Portrait Painters*, exh. cat. (London, Royal Institute, 1892), no. 166.

29 *Festa dell'Arte e dei Fiori*, exh. cat. (Florence, 1896–97), no. 44.

30 *Secession*, exh. cat. (Munich, Königliche Kunstausstellungsgebäude, 1898), no. 100. The portrait is also reproduced in the catalogue.

31 P. Schultze-Naumburg, "Fernand Khnopff," *Die Kunst für Alle* 15, no. 19 (July 1, 1900), p. 447, with reproduction; V. Pica, "Artistici contemporanei: Fernand Khnopff," *Emporium* 16, no. 93 (September 1902), p. 173, with reproduction; M. G. Sarfatti, "Profili d'artisti: Fernand Khnopff," *Il Rinascimento*, April 20, 1906, p. 64; L. Dumont-Wilden, *Fernand Khnopff* (Brussels, 1907), p. 22.

32 Guillaume Vogels, Willy Finch, Jan Toorop, Théo van Rysselberghe, Dario de Regoyos, and even James Ensor betray to different degrees the impact of Whistler's work.

33 R. Jensen, *Marketing Modernism in Fin-de-Siècle Europe* (Princeton, 1996).

34 Apart from the engravings of Venice, Whistler exhibited at Les XX his *Arrangement in Black, No. 5; Portrait of Mademoiselle de C. . . . ; Nocturne in Blue and Silver, No. 1; Symphony in White, No. 3;* and *Arrangement in Grey and Green: Portrait of Mademoiselle Alexander.*

35 J.-K. Huysmans, "Whistler," *L'Art Moderne* 4, no. 26 (June 29, 1884), p. 213.

36 J. McNeill Whistler, "The Red Rag," *The Gentle Art of Making Enemies* (London, 1892), p. 12.

37 [É. Verhaeren], "Whistler à Bruxelles," *L'Art Moderne* 7 (1887), p. 310.

38 See R. Johnson, "Whistler's Musical Modes: Numinous Nocturnes," *Arts Magazine* 54, no. 8 (April 1981), pp. 164–76.

39 É. Verhaeren, "Le Salon des XX" [1886], in *Écrits sur l'Art*, vol. 1, 1881–1892 (Brussels, 1997), p. 244.

40 Of the portrait of violinist Pablo de Sarasate exhibited by Les XX in 1886 and which he discovered in his London studio, Whistler declares that "With a great simplicity of means, the artist manages to render, not photographic reality, in the manner of Bonnat and other painters concerned only with the material exactness of the features and

clothing, but, apart from the outward likeness, also the impression given by his model's personality." Verhaeren, "James M. Whistler," in Écrits sur l'art (note 31), p. 226.

41 The term is taken from the essay devoted by Verhaeren to Khnopff in 1887, repeating and condensing his articles published in magazine form in 1886. See Verhaeren, "Quelques notes sur Fernand Khnopff" [1887], in Écrits sur l'art (note 39), p. 261.

42 Verhaeren (note 41), p. 263.

43 The "earthy painting" of Henri van der Hecht (1841–1901)—as Verhaeren described it in 1882 on the occasion of an exhibition organized at the Cercle Artistique et Littéraire—continues the outdoor experimentation of Hippolyte Boulenger and Théodore Baron. In 1868 Van der Hecht had cofounded the Société Libre des Beaux-Arts (Free Fine Arts Society) in order to defend Realist aesthetics in Belgium. In 1902 Octave Maus was to render homage to him in the columns of L'Art Moderne. On Van der Hecht, see P. Lambotte, "Henri Van der Hecht," in Biographie Nationale, vol. 26 (Brussels, 1936–38).

44 Jeanne [Jules Destrée], "La Chronique artistique: L'Exposition des Vingt au Palais des Beaux-Arts," Journal de Charleroi, February 18, 1884.

45 Pierre Gervais, "A MM. Les Vingtistes," Journal des Beaux-Arts et de la Littérature 26, no. 3 (February 17, 1884).

46 C. Lemonnier, L'École belge de peinture, 1830–1905 (Brussels, 1906; Brussels, 1991), p. 133.

47 See R. Rosenblum, Modern Painting and the Northern Romantic Tradition: Friedrich to Rothko (London, 1975).

48 I have developed this aspect in Draguet (note 1), pp. 42–50.

49 C. van Lerberghe, Journal, vol. 1, 1821–29, Brussels, Archives du Musée de la Littérature, BR-ML 6949/1, fol. 29.

50 See M. Draguet, Ensor ou la fantasmagorie (Paris, 1999), pp. 72–78.

51 Jeanne [J. Destrée] (note 44).

52 "His art is all determination, spreading out solemnly and hieratically, traversed by a Gothic influence of the old, supreme masters. The result is a spirit of recollection and grandeur, total conviction, absolute tenacity, with knowledge and inspiration marching side by side and in step, toward the summits. Khnopff is the most thinking, the most analyzing, and the most deep-delving of Les XX." É. Verhaeren, "Exposition des XX," La Jeune Belgique 3 (February 15, 1884), p. 201.

53 On this painting, see M. F. MacDonald, James McNeill Whistler: Drawings, Pastels and Watercolours: A Catalogue Raisonné (New Haven and London, 1994), pp. 503–4.

54 J. McNeill Whistler to W. C. Alexander, undated, London, British Museum, 1958-2-8-21.

55 Whistler, 1834–1903, exh. cat. (Paris, Musée d'Orsay, 1995), p. 147.

56 Quoted in S. Starr, "Personal Recollections of Whistler," Atlantic Monthly 101 (April 1908), p. 532.

57 Quoted in Whistler, 1834–1903 (note 55), p. 147.

58 Huysmans (note 35), p. 213. We would emphasize these terms, the concatenation of which appears natural in the context of fin-de-siècle Decadentism, the juxtaposition of which, however, derives from the resistance of the subject and the arrangement's economy of means.

59 S. Canning, "Fernand Khnopff and the Iconography of Silence," Arts Magazine 44, no. 4 (December 1979), pp. 170–76.

60 L. D. Morrissey, "Isolation and the Imagination: Fernand Khnopff's I Lock My Door upon myself," Arts Magazine 53, no. 4 (December 1978), pp. 94–97.

61 P. Roberts-Jones, "Khnopff en perspective" [1979], in L'Alphabet des circonstances: Essais sur l'art des XIXe et XXe siècles, Académie royale de Belgique (Mémoires de la classe des beaux-arts) (Brussels, 1981), pp. 273–77.

62 See Japonisme, exh. cat. (Paris, Galeries Nationales du Grand Palais, 1988), nos. 40, 41.

63 G. Verdavaine, "L'Exposition des XX," La Fédération Artistique 13, no. 16 (February 13, 1886), p. 124.

64 On this subject, see G. Ollinger-Zinque, "Fernand Khnopff et la photographie,"

in *Art et photographie: Kunst in Camera* (Brussels, 1980–81), pp. 19–29.

65 *Catalogue de la vente de l'atelier du peintre Fernand Khnopff*, Brussels, Contemporary Art Archives of the Musées royaux des Beaux-Arts de Belgique, 3699.

66 This fund, donated by the Thibaut de Maisières family, is conserved in Brussels, at the Contemporary Art Archives of the Musées royaux des Beaux-Arts de Belgique.

67 S. von Baranow, "Franz Lenbach und die Fotografie," in *Die Kunst und das schöne Heim* 98, no. 12 (1986), pp. 913–17.

68 R. Barthes, *La Chambre Claire: Note sur la Photographie* (Paris, 1980), p. 18.

69 C. Baudelaire, "Salon de 1859," in *Oeuvres complètes*, text established, presented, and annotated by C. Pichois (Paris, 1976), vol. 2, p. 614.

70 E. Eastlake, "Photography" [1857], referred to in B. Newhall, *Photography: Essays and Images* (New York, 1980), pp. 93–94.

71 F. Khnopff, "Is Photography among the Fine Arts?—a Symposium," *The Magazine of Art* (1899), pp. 156–58. These texts are repeated in their entirety under the same title in the *Magazine of Art* on pages 102–5, 206–9, 253–56, and 369–73. In 1916 Khnopff picked up the argument again in a lecture on "so-called art" photography given to the Classe des Beaux-Arts de l'Académie royale de Belgique.

72 F. Khnopff, "À propos de la photographie dite d'art," in *Annexe aux Bulletins de la Classe des Beaux-Arts: Communications Présentées à la Classe en 1915–1918* (Brussels, 1919), dated June 8, 1916, p. 95.

73 Khnopff (note 72), p. 97.

74 This refers to a practice that was in vogue at the time as much in popular circles—running from *crèches vivantes* to music hall acts, and even including the Musée Castan—as in high society evenings and certain international events like the Ghent Universal Exhibition of 1913, where Albert de Vriendt's canvas *Homage to the Young Charles V*, painted in 1886, was the subject of a live presentation.

75 Khnopff (note 72), p. 97.

76 Khnopff (note 72), p. 97.

77 Khnopff (note 72), p. 97.

78 H. Damisch, *Les origines de la perspectives* (Paris, 1987), pp. 343–46.

79 P. Bourdieu, *Un art moyen* (Paris, 1965), pp. 108–9.

80 Barthes (note 68), p. 74.

81 D. Arasse, *Le Détail: Pour une histoire rapprochée de la peinture* (Paris, 1992).

82 J. Green-Lewis, *Framing the Victorians: Photography and the Culture of Realism* (Ithaca and London, 1996), p. 69.

83 F. Brunet, *La Naissance de l'idée de photographie* (Paris, 2000), p. 155.

84 G. Batchen, *Burning with Desire: The Conception of Photography* (Cambridge, Mass., and London, 1997), p. 85.

85 H. von Amelunxen, *Die aufgehobene Zeit: Die Erfindung der Photographie durch William Henry Fox Talbot* (Berlin, 1989).

86 See E. Droescher, *Kindheit im Silberspiegel* (Dortmund, 1983); and L. Matta, *Bambini in posa: Una storia dell'infanzia in 150 anni di fotografia* (Scandicci, 1991).

87 Unlike Carroll, Khnopff does not seek to enter into an intimate relationship with his model, which would turn the image into a not-of-this-world enclave—this imaginary world, revealed "through the looking-glass," where social conventions and the rules of polite adult society no longer apply. See H. Gernsheim, *Lewis Carroll Photographer* (New York, 1969), p. 12.

88 M. N. Cohen, *Reflections in a Looking Glass: A Centennial Celebration of Lewis Carroll, Photographer* (London, 1999), p. 19.

89 M. Haworth-Booth, "The Photographic Moment of Lewis Carroll," in Cohen (note 88), p. 127.

90 Gernsheim (note 87), p. 29.

91 V. Hamilton, *Annals of My Glass House: Photographs by Julia Margaret Cameron* (Seattle, 1996).

92 Anonymous, "L'Art et les procédés mécaniques," *L'Art Moderne* 1, no. 40 (December 4, 1881), p. 315.

93 This question has been examined further at a theoretical level by P. Junod, *Transparence et opacité: Essai sur les fondements de l'art moderne: Pour une nouvelle lecture de Konrad Fiedler* (Lausanne, 1975).

94 Anonymous, "L'Art et les procédés mécaniques" (note 92), p. 315.

95 I. van Cleef, "L'Exposition des XX à Bruxelles," *Revue Artistique* 6, no. 189 (March 15, 1884), p. 319.

96 See, by way of example, Anonymous, "Variétés: Exposition du Cercle des XX," *Le Nord*, February 13, 1886, pp. 13–14; Verdavaine (note 63), p. 124.

97 Anonymous, "À Propos du Salon de L'Essor," *La Jeune Belgique* 2 (1882–83), p. 354.

98 P. Philippot, "Icône et narration chez Memling," in *Pénétrer l'art: Restaurer l'œuvre: Une vision humaniste: Hommage en forme de florilège* (Bruges, 1990), p. 77.

99 D. de Vos, *Hans Memling: L'œuvre complet* (Antwerp, 1994), p. 71.

100 F. Khnopff to Paul Schultze Naumburg, Brusells, 1899, Berlin, private collection, reproduced in Delevoy, de Croës, and Ollinger-Zinque (note 1), p. 27.

101 The costume, the bonnet, and the pose of *A Page*, painted in 1899, make reference to works like the *Portrait of the Man with a Coin* in the Antwerp museum, which he copied about 1914. Khnopff also drew inspiration from Memling's feminine figures for little drawings like *The Musician* produced about 1899. In it we find a preciosity that assimilates Pre-Raphaelite femininity to the Christian mystery.

102 On Leys, see, apart from Gustave Vanzype's monograph (Brussels, 1934), *Schilderkunst in België ten tijde van Henri Leys (1815–1869)*, exh. cat. (Antwerp, Koninklijk Museum voor Schone Kunsten, 1969).

103 W. H. J. Wheale, *Hans Memling* (Bruges, 1871). On the rediscovery of Memling in the nineteenth century, see L. Van Biervliet, "De roem Memling," in D. Devos, ed., *Hans Memling: Essays* (Ghent, 1994), pp. 109–24.

104 M. Leonard, Analysis Report: Fernand Khnopff, "Jeanne Kéfer." Laboratory #1953-P-00, Los Angeles, The Getty Conservation Institute–Museum Research Laboratory, September 18, 2000.

105 "A paintbrush, that is the brain. The knife, on the other hand, is the blunt instrument of a manual worker— unconscious, irresponsible, mechanical. It guides the hand, it cooperates with chance, even in the hands of a virtuoso it retains its hereditary soiledness, which turns into matter everything it touches. It is the knife that has engendered "more or less" painting. The masons of the art have found it convenient to do their work with a trowel. This simplifies research, one can forgo painting and drawing. An enormous sigh of relief is heard among the lazybones who are numerous in the world of art." C. Lemonnier, *Gustave Courbet* (Paris, 1878), p. 62.

106 É. Verhaeren, "Silhouettes d'artistes: Fernand Khnopff," *L'Art Moderne* 6, no. 37 (September 12, 1886), p. 290.

107 Anonymous, "Une fabrique de tableaux," *Chronique des Arts*, April 14, 1888, p. 108.

108 L. Solvay, "Le Salon des XX," *La Nation*, February 20, 1886; and Anonymous (note 96), p. 13. Recognized in 1879 for his *Charles V as a Child*, Van Beers enjoyed a relative fame that allowed him to set up in Paris one year later. Nothing exists to show that Khnopff associated with him. Nonetheless, they had certain things in common: first of all, a shared admiration for Alfred Stevens, in whose studio Van Beers was to work and who for Khnopff was one of the revelations of the 1878 Exposition Universelle. Van Beers's academic realism is attached to the industrial exploitation of photography. A series of scandals and lawsuits kept him in the public eye in the 1880s.

109 Solvay (note 108).

110 E. Panofsky, *Les Primitifs flamands* (Paris, 1992), p. 268.

111 J. McNeill Whistler to Octave Maus, February 1, 1884, and February 6, 1886, Brussels, Archives de l'Art Contemporain, Musées royaux des Beaux-Arts de Belgique, 1/4646 and 1/4763.

112 A. C., " Salon des XX: L'impressionnisme de Whistler," *La Réforme*, February 13, 1886.

113 Puck, "Petits vers de XX," *La Chronique*, February 18, 1886.

114 See M. Draguet, *Cabinet de dessins: Félicien Rops* (Paris, 1999), pp. 118–23.

115 E. A. Mendgen, *Künstler rahmen ihre Bilder: Zur Geschichte des Bilderrahmens zwischen Akademie und Sezession* (Konstanz, 1991), pp. 102–39.

116 On this problem area of the framing of Khnopff's paintings, see Draguet (note 1), pp. 209–23.

117 In 1889 Khnopff reverted to this formula for one variant of *My Heart Weeps for Earlier Days*, but using a different technique.

118 A label glued to the back of the *Portrait of Marguerite* provides some information as to the construction of the framing. The frame was produced by the Ateliers Jean Luadeck, 10, rue du Gouvernement Provisoire, in Brussels, to Khnopff's instructions. The painter appears to have used this skilled firm for many of his works: *The Blue Wing*, *Acrasia*, and *Study for a Shoulder* also carry mentions of this workshop.

119 We find here a central principle of the concept of the icon as formulated in Byzantin in the eighth century in such theological texts as Patriarch Nicephorus's *Discourse against the Iconoclasts* (Discours contre les iconoclastes: Discussion et réfutation des bavardages ignares, athées et tout à fait creux de l'irreligieux Mamon contre l'incarnation de Dieu le Verbe notre Sauveur), translation, presentation, and notes by M.-J. Mondzain-Baudinet (Paris, 1989).

120 Nicephorus (note 119), p. 25.

121 Hypnotized by the emerald eyes of the statues, the unfortunate duke of Fréneuse can confess: "Yes, to drown in them like Narcissus at the fountain, there would joy be. The madness of the eyes is the attraction of the gulf. There are sirens at the bottom of the apples of their eyes, as at the bottom of the sea." J. Lorrain, *Monsieur de Phocas*, pp. 29–30.

122 Khnopff (note 72), p. 99.

123 Draguet (note 1), pp. 73–77. On the anthropological value of the Medusa myth, see J. Clair, *Méduse: Contribution à une anthropologie des arts visuels* (Paris, 1986). On the iconography of Medusa, see *Zauber der Medusa: Europäische Manierismen*, exh. cat. (Vienna, 1987).

124 E. Droescher, *Puppenwelt* (Dortmund, 1978).

125 I thank Marguerite Coppens, curator at the Musées royaux d'Art de d'Historire, Brussels, for providing me with this information obtained from a detailed reading of the late-nineteenth-century feminine press. A systematic study of these sources, neglected by traditional art history, would enable us to better situate the image of woman, not only in the painter's work but also in his thought.

126 For an analysis of this canvas, see Draguet (note 1), pp. 64–69.

127 See J. Goody, *La Culture des fleurs* (Paris, 1994).

128 B. Schrœder-Gudehus and A. Rasmussen, *Les fastes du progrès: Le guide des Expositions Universelles, 1851–1992* (Paris, 1993), p. 100.

129 *L'Illustration* 72, no. 1855 (September 14, 1878), p. 174.

130 É. Gallé, "Le décor symbolique" (1900), in *Écrits pour l'art: Floriculture—Arts décoratifs—Notices d'exposition* (1884–1889) (1908), preface by F. T. Charpentier (Marseille, 1980), pp. 210–28. See also P. Thiébault, *Les dessins de Gallé*, exh. cat. (Paris, 1993), chapter 3.

131 C. de Latour, *Le langage des fleurs, ou le Selam de l'Orient*, quoted in Goody (note 127), p. 275.

132 Describing her visit to Khnopff's house, Maria Biermé presents the artist in his studio: "On the first floor, the Master remained immobile in a large luminous room, its walls covered in sumptuous marble mosaics. Next to him, on the floor, a small vase containing a delicate flower, in front of him an easel. Dazzled, we looked all around us when the Master made a gesture toward the ground, where we noted a large gilded circle some four meters in diameter. This circle was essential, he told us, for him to be in a condition to paint. At the center of the magic circle, a flower at his side, inspiration came from above." M. Biermé, *Les Artistes de la pensée et du sentiment* (Brussels, 1911), p. 38.

133 See P. Knight, *Flower Poetics in Nineteenth-Century France* (Oxford, 1986).

134 A. Martin, *Le langage et emblème des fleurs*, 12th ed. (Paris, 1835), p. 162.

135 A. van Wijlen, *Encyclopédie des plantes de Jardin* (Aartselaar, 1980), p. 160.

136 A. Rey, ed., *Dictionnaire historique de la langue française* (Paris, 1992), p. 1052.

137 Van Wijlen (note 135), p. 162.

138 *Vanille et orchidées*, exh. cat. (Grasse, Musée international de la Parfumerie, 1993), chapter 1.

139 The mystical herb garden of the Christian tradition incarnates Our Lady's tresses in the devotional bouquets offered to Mary. Anonymous, "Sacred Trees and Flowers," *Quarterly Review*, no. 114 (1863), pp. 210–50.

140 Anonymous (note 139), p. 422.

141 *Views from Jade Terrrace: Chinese Women Artists, 1300–1912*, exh. cat. (Indianapolis, Indianapolis Museum of Art, 1988), p. 74.

142 S. Freud, *The Interpretation of Dreams*, taken from the French, *L'interprétation des rêves*, trans. I. Meyerson (Paris, 1967), p. 323.

143 A. Thiercé, *Histoire de l'adolescence et des adolescents (1850–1914)* (Paris, 2000).

144 Solvay (note 108).

145 J. Block, "Théo Van Rysselberghe peintre aux multiples facettes: Génèse d'un portraitiste néo-impressionniste," in *Théo Van Rysselberhe néo-impressionniste*, exh. cat. (Ghent, Museum voor Schone Kunsten, 1993), pp. 5–25.

146 T. van Rysselberghe to Octave Maus, October 2, 1885, Brussels, Archives de l'Art Contemporain, Musées royaux des Beaux-Arts de Belgique, 11.978.

147 The adopting of Neo-Impressionist handling in 1888 was to point Van Rysselberghe's work decisively in the direction of "Arrangements" that are more in line with his fundamental nature. The principle of harmony— limited here to the palette of Whistler's *Nocturnes*—was to find a new formulation. See Block (note 145). On Neo-Impressionist portraiture, see J. Block, "A Study in Belgian Neo-Impressionist Portraiture," *The Art Institute of Chicago Museum Studies* 13 (1987), pp. 36–51.

148 Solvay (note 108).

149 F. Khnopff, *L'enchantement de Merlin*, p. 18.

150 Verhaeren (note 23).

151 Known only by a description, "Against the somber blue background of her boudoir, with hallucinating reflections, the princess d'Este, the divine daughter of Hercules, stood up straight, naked, adorably white, and as if enhaloed by the tawny cascade of her golden hair! Her eyes fixed, her body taut with effort, she advanced her arms to remove obsessive Desire, and, in the dark, like lights or eyes, radiated the double white patches of two mysterious lilies! A perverse, feminine dream, of suble refinement, hovered in this strange drawing, interpreting Péladan's strange work with a rare understanding." Anonymous, "Chronique artistique: L'Exposition des XX," *Journal de Charleroi*, February 27, 1885.

152 I have traced the full story in *Khnopff ou l'ambigu poétique* (note 1), chapter 3.

153 F. K[hnopff], "Lettre de Fernand Khnopff," *La Réforme*, February 24, 1885.

154 Péladan, quoted in Picard (note 156).

155 O. Maus, "Lettre à Azed," *L'Indépendance*, February 27, 1885.

156 E. Picard, "L'incident Caron," *L'Art Moderne* 5, no. 9 (March 1, 1885), p. 65.

157 Picard (note 156), p. 66.

158 Picard (note 156), p. 66.

159 "Her dazzlingly matte skin colors are those of Ingres's *La Source*, without any pink highlighting; the paleness of her thin arms, an exhausted depression, continues into her hands, with their long thumbs, and into her shoulders bearing her long neck. A marble princess, with proud demeanor, thin lips, large mouth, disturbing smile, scornful pucker of the forehead, and strident laugh. Fine hair with flaves-cences of old gold, her plaits rolled at the neck in a simplicity more fearful than any ornament. This disturbing neck with this blond cloud from which descends the dorsal furrow in a long, narrow valley of enchantments. Her sea-green eyes with their direct, ambiguous stare, a boldly chiseled forehead on which is written the spirit of revolt, naked like the figures Bronzino painted. A voice which is never raised when conversing, a body of which every

gesture is languid; her outline swelling slightly at the flanks and, under the clothes that follow it, losing itself in the long legs of an Eve by Lucas van Leyden. The rake of her contours, the narrow length of her extremities, the reign of the verticals; an angel taken from a missel." Péladan, quoted in Picard (note 156).

160 J. Ensor, "Les Aquarellistes d'aujour-d'hui: Parodies, réflexions et lignes cari-caturales" (1914), in Mes écrits (Liège, n.d.), p. 65.

161 Delevoy, de Croës, and Ollinger-Zinque (note 1).

162 A detailed analysis of this painting can be found in Draguet (note 1), pp. 104–11.

163 J. de Palacio, Messaline décadente ou la figure du sang: Figures et formes de la décadence (Paris, 1994), p. 117 note 70.

164 The 1862 White Girl has produced con-tradictory interpretations, depending on whether seen in London or Paris. An evocation of Wilkie Collins's novel The Woman in White for the British, she changes into a psychic fantasy for the French, who like to see in her the day after the marriage night. On these interpretations, see H. Taylor, James McNeill Whistler (n.p., 1978), p. 27.

165 M. Fried, Absorption and Theatricality: Painting and Beholder in the Age of Diderot (Berkeley, 1980), pp. 113–65.

166 F. Khnopff, "The Art of the Late Alfred Stevens, Belgian Painter," The Studio, no. 49 (December 1906), p. 219.

167 R. de Piles, quoted in D. Arasse, Le détail: Pour une lecture rapprochée de la peinture (Paris, 1992), p. 163.

168 L. Hevesi, Wiener Fremden-Blatt, April 24, 1898, quoted in Fernand Khnopff et ses rapports avec la Secession viennoise, exh. cat. (Brussels, Musées royaux des Beaux-Arts de Belgique, 1987), p. 75.

169 Hevesi (note 168), p. 82.